OLDBURY, LANGLEY & WARLEY

THROUGH TIME

Dr Terry Daniels

AMBERLEY PUBLISHING

Acknowledgements

The 'now' pictures were all taken by the author. The 'old' pictures come from the author's collection of photographs and postcards, Langley Local History Society's postcard collection, Sandwell Community History and Archives, various old publications, and the many individuals who have allowed their photographs to be scanned into the picture collections of the local history societies. Over thirty individuals are represented by one or two pictures, and the author is grateful to all of them. One who should be specifically mentioned is Janet Smith, who took many pictures of Oldbury from the 1970s to the 1990s when Oldbury was changed radically: ten of her pictures are included.

Further information on Oldbury's history can be found on the website: www.historyofoldbury.co.uk

First published 2012

Amberley Publishing
The Hill, Stroud
Gloucestershire, GL5 4EP

www.amberley-books.com

Copyright © Dr Terry Daniels, 2012

The right of Dr Terry Daniels to be identified as the Author of this work has been asserted in accordance with the Copyrights, Designs and Patents Act 1988.

ISBN 978 1 4456 0543 2

British Library Cataloguing in Publication Data. A catalogue record for this book is available from the British Library.

Typeset in 9.5pt on 12pt Celeste.
Typesetting by Amberley Publishing.
Printed in the UK.

Introduction

Three Villages

A thousand years ago, Oldbury, Langley and Warley were three 'vills', small settlements that were part of the Manor of Hales (Halesowen), and too small to be mentioned individually in the Domesday Book. Hales Manor came under the control of Hales Abbey in 1215, and the manor court rolls show that all three vills sent representatives to the court.

Hales Abbey was surrendered to the King in 1538 at the dissolution of the monasteries, and Henry VIII sold the manor to Sir John Dudley. In 1557, his son, Robert Dudley, sold most of Hales Manor, including Warley, and it came into the possession of the Lyttleton family. However, he held on to Oldbury and Langley, creating Oldbury Manor.

From this time, Warley developed separately, until local authority structures were revised, and Warley once again joined with Oldbury and Langley to form the new Oldbury Urban District in 1894. In 1935 the Urban District gained its charter from George V and became the Borough of Oldbury. This independence lasted until 1966, when it merged with Rowley Regis and Smethwick to create the County Borough of Warley. This authority was short-lived, however, and a further merger with West Bromwich in 1974 saw the creation of the Metropolitan Borough of Sandwell, where Oldbury, Langley, and Warley are now to be found.

Sandwell Council changes its definition of 'Oldbury' from time to time, moving wards in and out as they see fit. This book covers the land included in Oldbury in the first half of the twentieth century. Even this was subject to change: in 1928 some land was gained from Cakemore and some lost to Smethwick.

Expansion

Oldbury and part of Langley lie on the South Staffordshire coalfield: theirs is a story of canals, coal mining, industrial development, and rapid growth from the late eighteenth century. However, Warley and the remainder of Langley lie off the coalfield: they remained rural until well into the twentieth century.

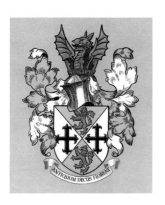 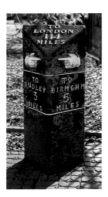 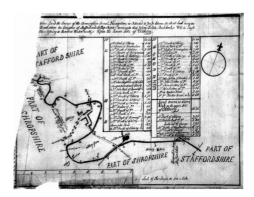

Above left: Oldbury's Coat of Arms, granted in 1926.

Above middle: The Milestone in Oldbury churchyard from turnpike days.

Above right: Brindley's map of the proposed canal around Oldbury, drawn about 1767, showing the owners of land that it would cross.

The whole area was agricultural in the mid-1700s. The one significant cottage industry was nail-making. Several water mills remained, some being converted from the grinding of corn to the forging of iron or the honing of blades. The road through Oldbury was made into a turnpike, but it was still a poor muddy track, making transport difficult.

Two changes occurred around 1770: a canal was cut through Oldbury, and the first significant mining operations were extended into the area. The canal was built by James Brindley for the Birmingham Canal Company to transport coal from mines at Wednesbury and Tipton to the workshops of Birmingham. Now Oldbury had a good transport link, and basins and wharves were soon established in the town.

Industries sprang up, one of the earliest being William Hunt and Son, the Brades, making edge tools. Local coal and iron ore led to the building of blast furnaces and an extensive iron industry. The opportunity for work attracted people from all over the country: miners from Somerset and Shropshire, farm workers from the rural Midlands, and men and women from Ireland after the potato famine in the 1840s.

Oldbury became a boom town. The population expanded from under 4,000 in 1800 to 25,000 in 1900, with a growing need for houses. Much of the new housing was poor quality and most workers lived in damp, overcrowded conditions. Their work was dangerous, hard, and unhealthy. By the mid-1800s the land around Oldbury was blighted by pit mounds, spoil heaps, marl holes and chemical dumps. It was not a good place to live and work.

Improvements

Gradual improvements were made throughout the Victorian era. Churches and chapels were built and many of these ran the first schools. Christchurch opened in 1841 and Trinity Church, Langley, in 1852. There were nine Methodist and six other non-conformist chapels in 1851. The St Francis Xavier Roman Catholic Church was erected in 1865.

Rudimentary local authorities were established: a Highway Board in 1836, replaced by a Local Board of Health in 1857. There was always reluctance from the few ratepayers to provide facilities for all the townsfolk to use! Nevertheless, basic amenities were slowly introduced: piped water (1870s), gas (1880) and sewage disposal (1895). The railways arrived in 1852, trams in 1885 (first horse-drawn and later steam-hauled), electric trams in 1904 and buses in 1914.

As working hours reduced in the twentieth century, people enjoyed more leisure. New entertainments arose in the form of social clubs, cinemas, sports facilities, and parks. The Urban District Council built new schools, council houses to replace slums, libraries, swimming baths, and sports facilities.

Coal mining and iron extraction declined in the late nineteenth century, and mining ceased altogether in the 1920s. However, the forging, casting, and fabrication of iron and steel grew with products such as railway carriages, boilers, tubes, and water and sewerage plant. This heavy industry, together with brick making and the manufacture of chemicals and plastics, continued until well after the Second World War. Now many of these industries have gone, the spoil heaps are levelled, the factories demolished, and small industrial units, warehouses, or supermarkets replace them.

Housing continued to be built after the Second World War with new council estates at Brandhall and Lion Farm. When Oldbury lost its independence in 1966, its town centre became neglected, but from the late 1970s, large parts of Oldbury and Langley were redeveloped. The centre of Oldbury received a boost from the 'Savacentre' (now Sainsbury's) and Sandwell Council House, but these required the removal of chapels, schools, houses, the Palace cinema, and other reminders of Oldbury's origins. Both Langley and Langley Green had their old street patterns obliterated and new houses built.

Changes continue and more of historic Oldbury, Langley and Warley is lost month by month ...

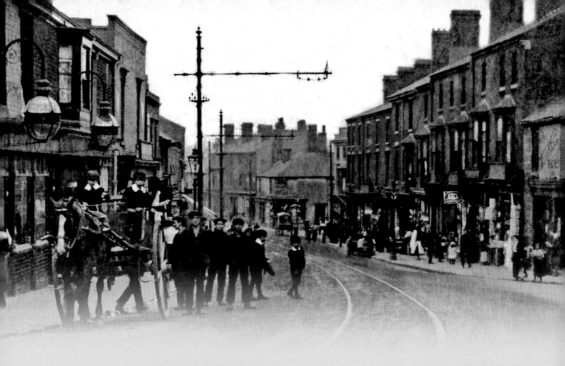

CHAPTER 1

Oldbury & Rounds Green

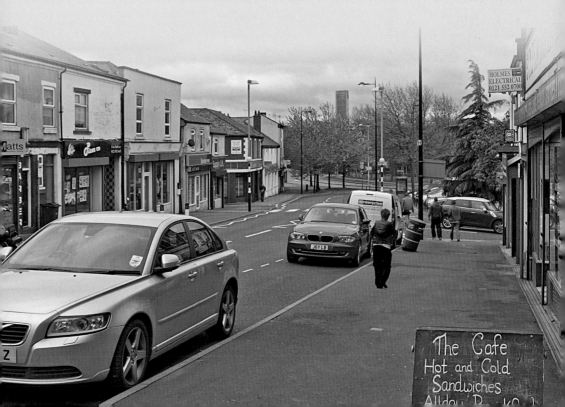

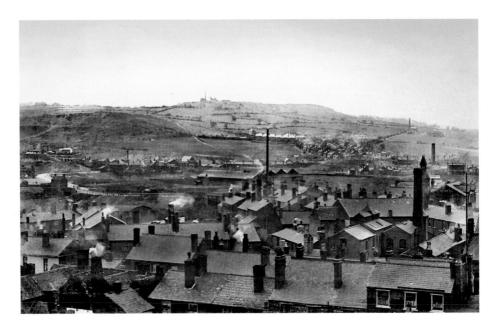

The Rowley Hills from Christchurch Tower

By 1911, when this photograph was taken, coal mining had declined rapidly, largely because the battle to prevent flooding of the pits was being lost. However, the Rowley Hills clearly show the scars of past mining and quarrying. Several engine houses are visible, as is the large spoil bank of Alston Colliery. In the middle distance are the industrial buildings and brickworks of Rounds Green. A path leads up to Bury Hill Park (the green strip behind the pylon in the 2008 picture). Despite the spread of housing estates, some open land remains on the Rowley Hills today. The houses, shops and churches in the foreground have been swept away by the developments of the last thirty years.

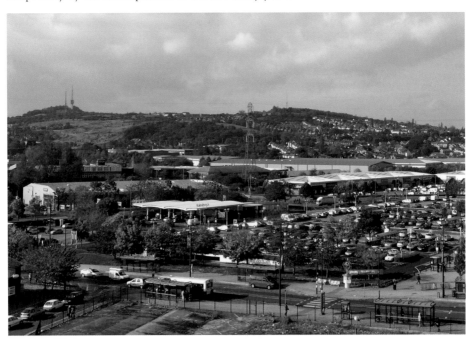

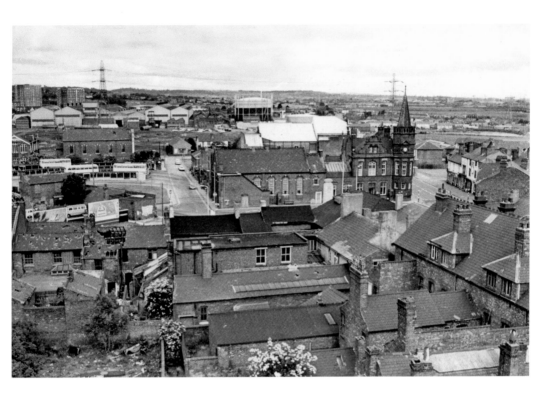

The Centre of Oldbury from Christchurch Tower

There are significant differences in Oldbury town centre between these two pictures, taken in the 1970s and 2008. The town hall has been replaced by Sainsbury's, but the old public offices with their distinctive spire were preserved. The bus station, the Tabernacle Chapel, and several old streets were removed for the store's car park. The houses and shops of Freeth Street and Orchard Street made way for Sandwell Council House. In the distance the gasworks and the flats at Brades Rise have gone. Even the 2008 picture is different now: the open area to the bottom left now contains 'Jack Judge House', the new library and council offices, opened in March 2011.

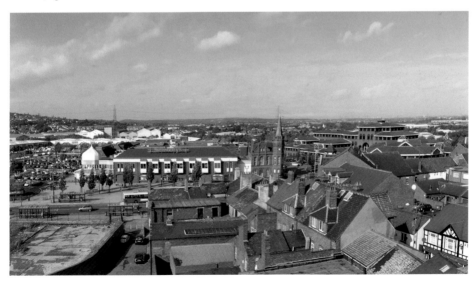

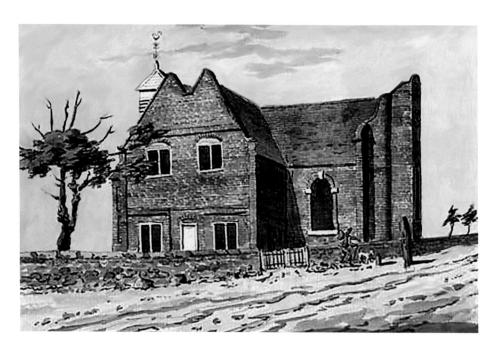

Oldbury Town Square I

The 'Town Square' or 'Market Place' was the focus of Oldbury life, but it has seen many changes since it was a rutted, muddy square, where the roads from Halesowen, West Bromwich, Dudley, and Birmingham all met. The upper picture, a sketch made in 1800, is the only known image of Oldbury Chapel, which was opened in 1529 as a chapel of ease to the parish church at Halesowen. It stood on one side of the square with the animal pound opposite. The chapel was demolished in the 1840s, leaving the old graveyard, which was later made into gardens.

The Town Hall, originally a Temperance Hall, was built in 1856, and the Public Buildings and Library opened in 1891. The lower picture dates to 1904, when the horse-drawn trams were being replaced by electric trams. The uprights for the tramwires are in place, but the electric wires have yet to be installed.

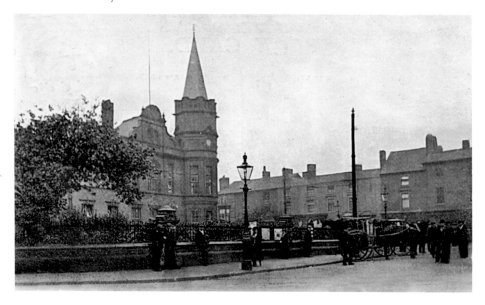

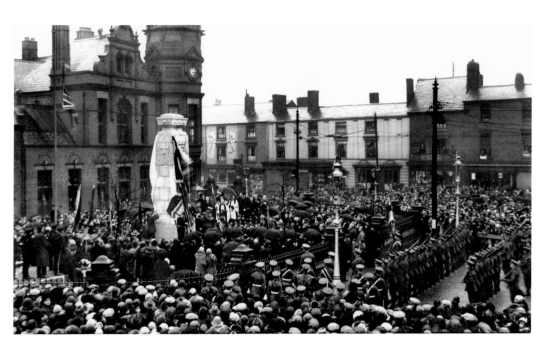

Oldbury Town Square II

The Cenotaph was unveiled in the gardens in November 1926 as a memorial to the dead of the Great War. Its dedication has been extended to cover the fallen of the Second World War and other conflicts. Shortly afterwards, the gardens were removed and the town square was redesigned to ease the flow of traffic, and provide a bus station and turning place for Midland Red and West Bromwich Corporation buses. The trams continued to run on Route 86, Birmingham to Dudley, until 1939.

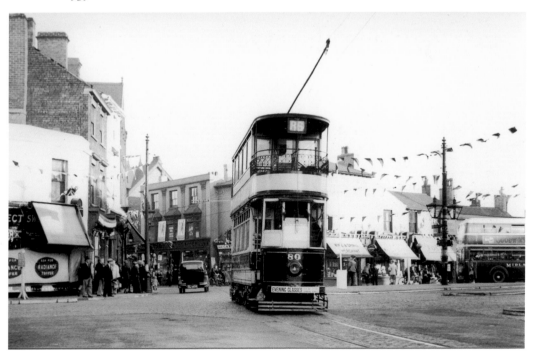

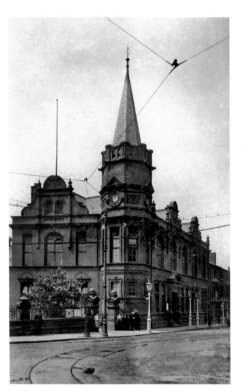

The Public Buildings and Library

The Public Buildings and Library were opened in 1891, when the 'local authority' was Oldbury Board of Health. Three years later it became an Urban District Council. The public buildings housed the main council departments, with the council chamber situated on the first floor of the tower. A free library, the first in the town, was opened at the same time with a stock of about 2,000 books, half of which were 'suitable and not unimproving' fiction! It was on the ground floor, and remained until 1977 when the site was redeveloped. It then moved a short distance to the old court building in Church Street, and in 2011 moved to the striking new building in the town square, Jack Judge House.

In the picture below, people hurry home on a damp December day in 2000, with the town's Christmas tree already lit up. Further changes have been made to the design of the square since then, and Freeth Street, on the right, is no longer accessible to traffic.

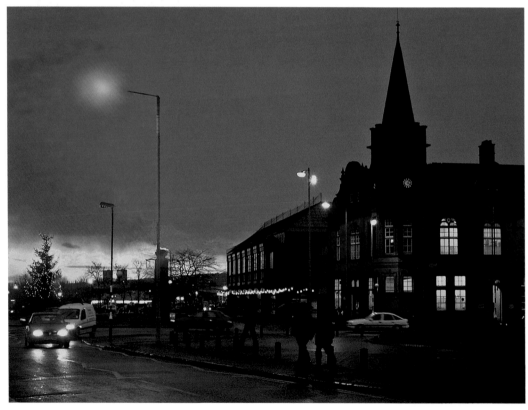

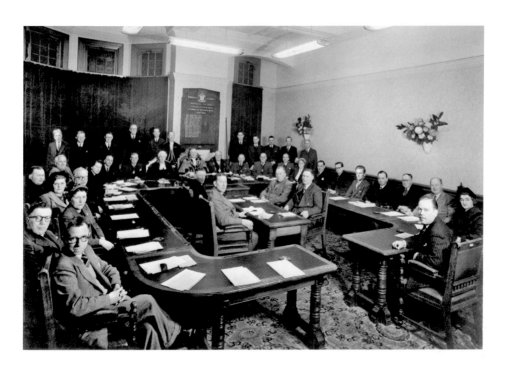

Oldbury Council

Oldbury Council pose in 1952 in the Council Chamber, when Samuel Melsom was Mayor. The windows of the tower are on the left side, behind the screen. Oldbury is now part of the Metropolitan Borough of Sandwell, and the new Council House for Sandwell is situated in Oldbury facing the old Public Buildings across the pedestrianised area of Freeth Street.

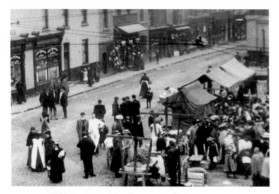

Oldbury Market

Oldbury Urban District Council bought the market rights from the Lord of the Manor in 1895, and a regular market was established in the town square. This was particularly popular on Saturdays, and the stalls were lit by naphtha flares in the dark evenings. The top picture shows the market in the early 1900s.

As traffic increased, it became impractical to hold a market in the square. It was moved to land behind the Bull's Head in Birmingham Street, and entered through an opening next to the public house. The middle picture shows the market in the 1970s, not long before it was closed for development. The last redesign of the town square created a large open pedestrian area, and a small market has returned close to the original market site.

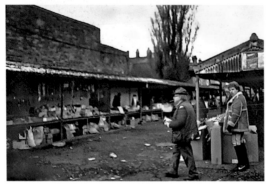

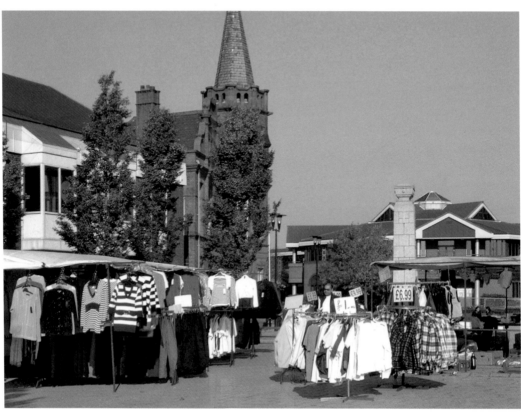

The Superstore

When Oldbury ceased to be an independent borough in 1966, the town centre went into a decline, but this was reversed with the building of the 'Savacentre' in 1980. This large development destroyed the old street pattern and many buildings including the Town Hall, several chapels, the Palace cinema, and the Old Talbot Hotel.

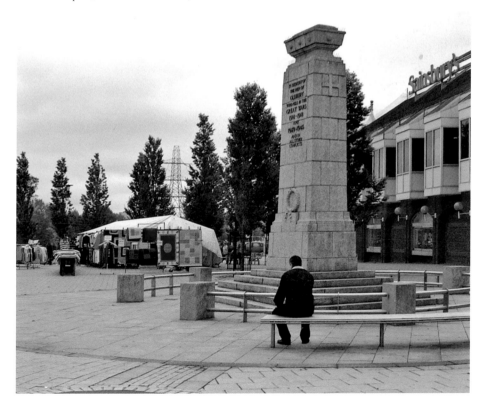

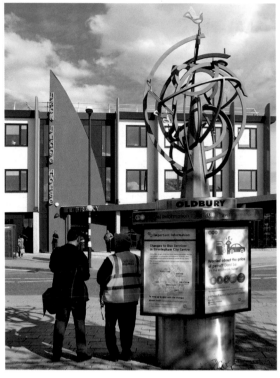

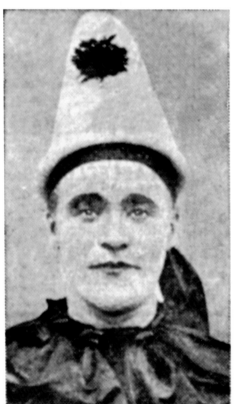

Jack Judge House

Oldbury Town Square now has a striking new building, Jack Judge House, which contains council offices and Oldbury Library. It was opened by the Mayor of Sandwell, Cllr Pauline Hinton, in March 2011. The proceedings were started with a call from Sandwell Town Crier, Adrian Holmes.

Jack Judge was born in Oldbury in 1872 and sold fish in the town. He wrote and performed songs, whistled tunes and told jokes in local music halls. The picture shows him in 1907 dressed as Pierrot. He progressed to the professional stage, and his fame was assured after his song 'It's a Long Way to Tipperary' became a marching song for troops in the First World War. He spent his life in Oldbury, and died in Hallam Hospital, West Bromwich, in 1936.

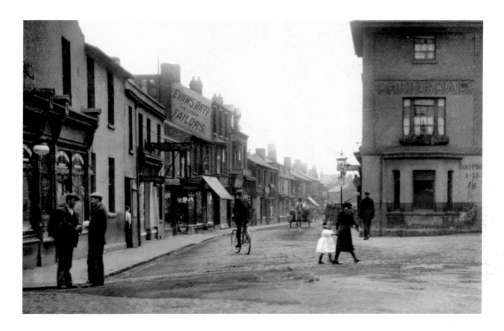

Halesowen Street

The top picture shows Halesowen Street and the Old Talbot Hotel around 1910. The hotel and buildings on that side of the street have all been demolished. On the other side of the road, the first few shops from the corner with Birmingham Street remain, brightly painted and giving character to the town square. Evans Bros, 'The Great Tailors', was destroyed by a bomb in the Second World War, which deposited most of their stock over the telephone wires in the area. This site was not fully redeveloped until Jack Judge House was opened there in 2011.

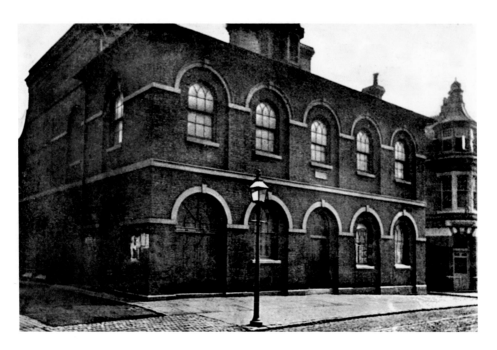

The Court House

The Court of Requests in Church Street was built in 1816 as the debtors' prison for Oldbury and other local townships. It included a jail at the rear, which was severely criticised by the Home Office in the 1840s for its squalid conditions. It then became the Magistrates' Court and the County Court. The County Court was transferred to West Bromwich in the 1880s, but the Magistrates' Court remained. The old prison was demolished. The court room, photographed in 2011, retains the fittings from its use by the magistrates, and is complete with dock, witness box, magistrates' bench and desks for the court officers.

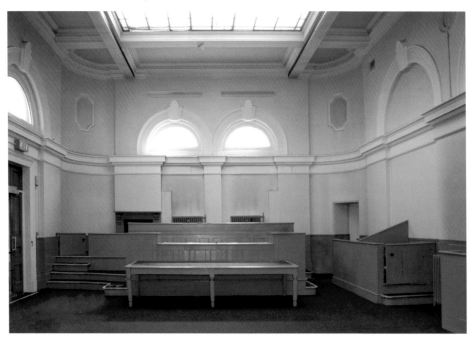

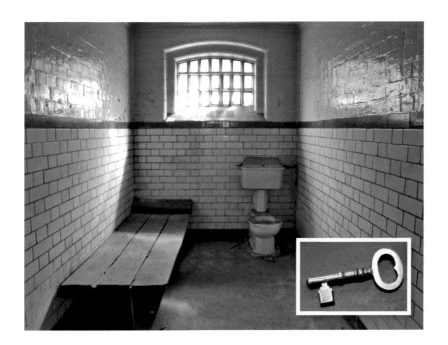

The Police Station

The police station moved there in the early 1900s, and new jail cells were built. The cells, photographed in 2011, are largely unchanged from the day the police left and very uninviting. The jailor's key is still essential for moving around the building. When the police and magistrates vacated the building in the 1970s, Oldbury Library moved into the building from the old Public Offices. In 2011, the library went to Jack Judge House. J. D. Wetherspoon bought the listed building, and it is now open as a restaurant, appropriately called 'The Court of Requests'. The Court Room and the police cells remain unchanged.

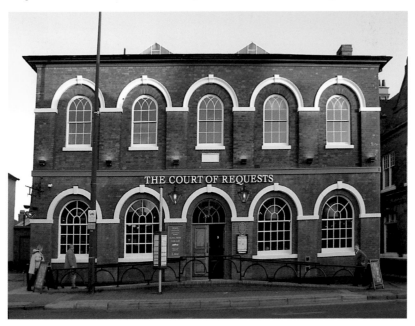

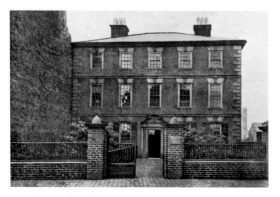

The Big House I

The Big House is a listed building in Church Street. It is the oldest building standing in the town and the nearest to a 'stately home' that is left. The house we see today dates from around 1730, but stands on older cellars, which were used as a prison in the mid-1800s. William Freeth, who owned much of the land in Oldbury, carried out the eighteenth-century renovation. It had barns, orchards, stables and other outbuildings, and occupied a prominent position at the highest point in Oldbury. In the 1850s the building and its immediate surroundings were sold and it became solicitors' offices. The land agents Jones, Son, & Vernon owned it until the 1990s, when it was bought by Sandwell Council. They refurbished it throughout, and it is now the Mayor's office. The pictures show the building in 1900, during its restoration around 2000, and as it is now. It makes a good contrast with its larger neighbour, Sandwell Council House.

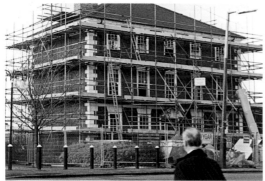

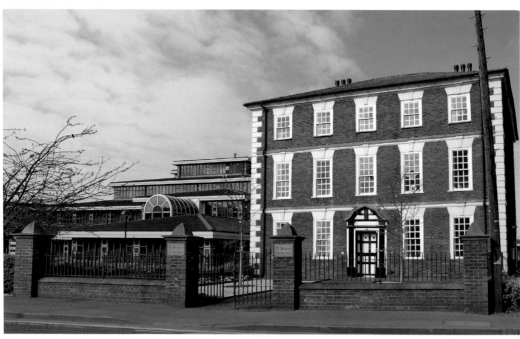

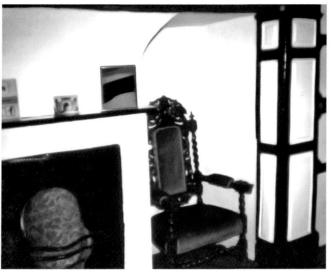

The Big House II
The interior of the Big House has been modernised from the days when it was a land agent's office. The front office is shown as it was in 1980, and now as the office of the Mayor of Sandwell. The original staircase, shown above, and an Adam-style fireplace were stolen in the 1990s, but excellent reproductions have been installed. The replacement fireplace is shown in the picture below.

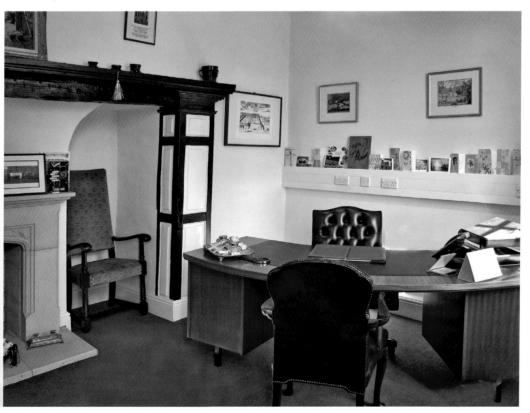

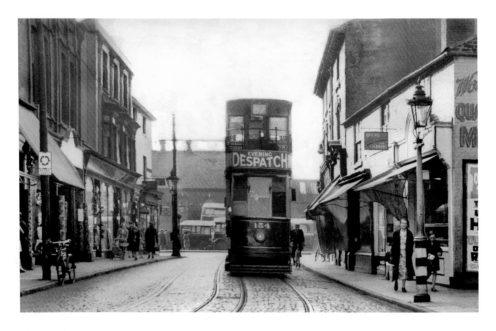

Birmingham Street I

The No. 86 or 87 tram went along Birmingham Street from Birmingham to Dudley. In this narrow section of Birmingham Street, the double tracks were so close together that two trams could not pass each other. The top picture was taken in 1939 when the lampposts had been painted with stripes to make them more visible in the expected blackout. Midland Red & West Bromwich Corporation buses wait at the bus station in front of the Town Hall. Most of the original buildings are still to be seen in the 2012 picture, although Sainsbury's has replaced the Town Hall in the distance.

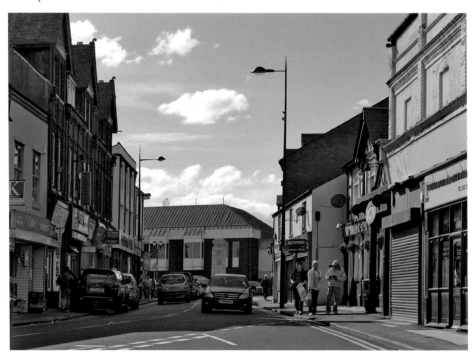

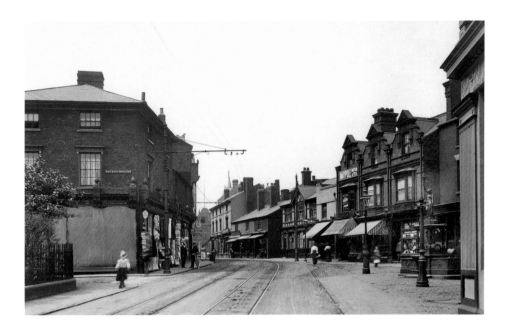

Birmingham Street II

This view of the top of Birmingham Street is largely unchanged a century on. The draper's shop on the left has its blinds down to protect the merchandise from the sun. In the 1930s this became the first branch of the Birmingham Municipal Bank outside the city, and now houses a branch of Lloyds TSB Bank. Unfortunately, some of the striking shop façades have been simplified. On the right of the old picture, is the drinking fountain with the statue of Europa, known locally as 'Polly-on-the-fountain'. This was damaged in 1949 and removed soon after: drinkers and smokers from the Junction public house now occupy the spot.

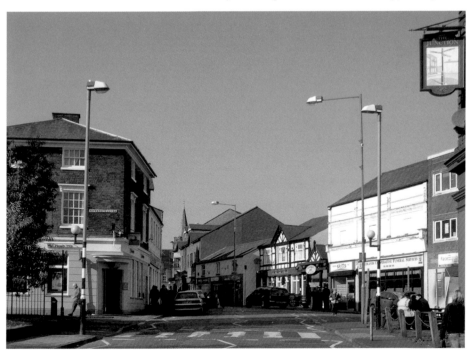

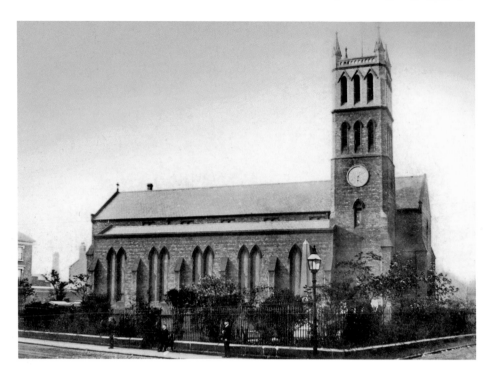

Christchurch

Oldbury was part of Halesowen Parish, but in 1841 Henry Pepys, Bishop of Worcester, consecrated Christchurch, and the town became a separate parish. Today, most of the tombs and headstones have gone from the churchyard and the trees are more mature, but the exterior of the church itself has changed very little.

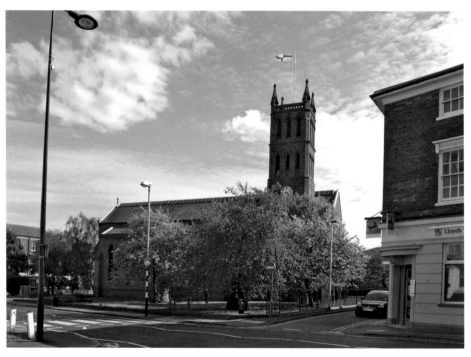

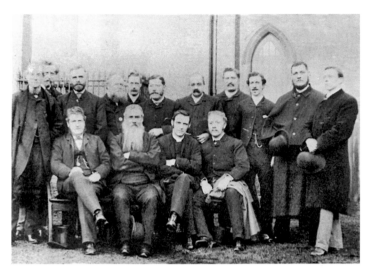

Churchyard and Tower

The top section of the tower in the old picture opposite is lighter in colour. This part was added in 1887 to accommodate a new peal of eight bells bought by public subscription to mark Queen Victoria's Golden Jubilee. The scheme was overseen by a committee of leading citizens, led by the vicar, Revd William Thomas Taylor, a popular man who sported a fine beard. The bells can no longer be swung to ring them, and, therefore, a striking mechanism was installed in 2009 after many years of silence. The picture shows the No. 7 bell, given by Alexander Macomb Chance. Climbing the tower to the roof is not for the faint-hearted! The church clock was installed in 1890, also by public subscription. The new ringing mechanism once again allows this to strike the hours and quarters. Behind the lamp in the old picture is this obelisk. It is a monument raised in memory of Theodore Pearsall, a brilliant young violinist from Oldbury, who died at the age of sixteen while studying at Berlin Academy in 1880.

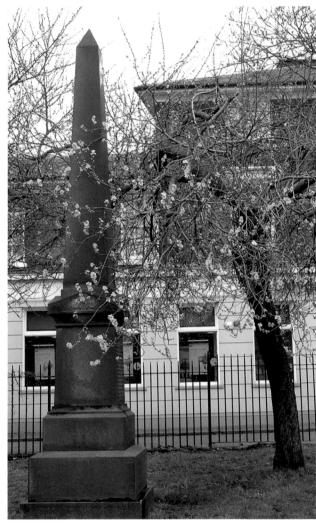

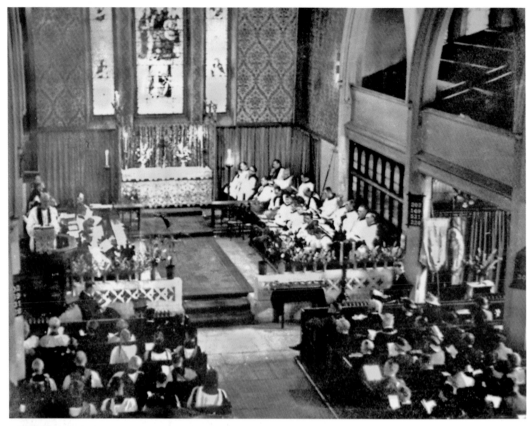

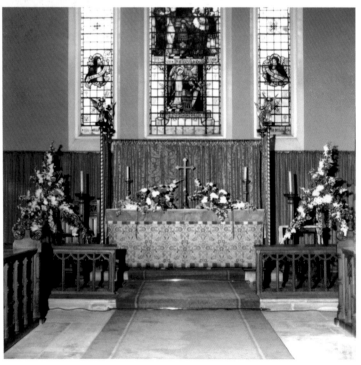

Christchurch Interior I
The centenary of Christchurch was celebrated in 1941, even if the festivities were somewhat muted because it was wartime. Its pews were well filled with clergy and local dignitaries, including the Mayor of Oldbury, Cllr C. T. Barlow. The sermon was preached by the Bishop of Birmingham. The sanctuary had not changed very much by 1977, lower picture, with curtains still behind the altar and along the east wall.

Christchurch Interior II

The east window of Christchurch is dedicated to William Chance (1788–1856), one of the founders of Chance Brothers glassworks at Smethwick. The present window was installed in 1914, replacing an earlier one destroyed in a storm. Its central panel shows Mary with the infant Christ with the angels, the star, and the wise men presenting their gifts.

Christchurch was threatened with closure and demolition in the 1980s, but saved by public outcry – largely from people who never worshipped there! Instead of demolishing the church, its nave was divided to make office accommodation at the west end, with a smaller worship space at the east end. In the course of this work the fine encaustic tiles behind the altar were re-discovered and now form the backdrop to the sanctuary. The church was re-dedicated by the Bishop of Birmingham on 25 February 1992.

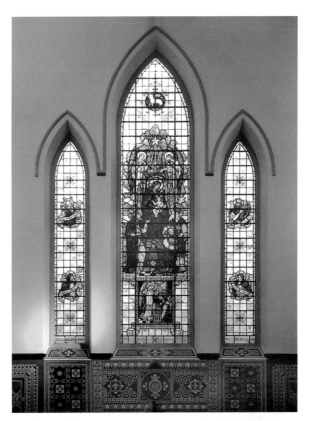

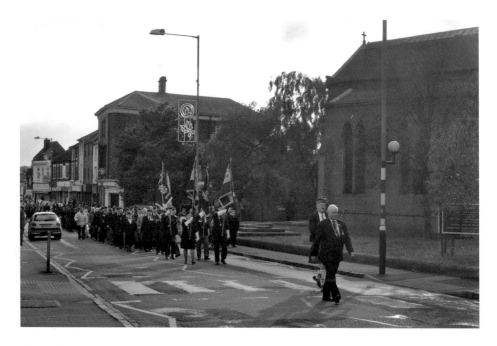

Remembrance

Of all the civic events, Remembrance Day is one of the best established, and features the annual parade to the Cenotaph led by the Oldbury Branch of the Royal British Legion. The old photograph dates from around 1930 when many families in Oldbury were still living with the consequences of the First World War. The recent picture shows the 2007 parade in the same place, passing Christchurch in Birmingham Street.

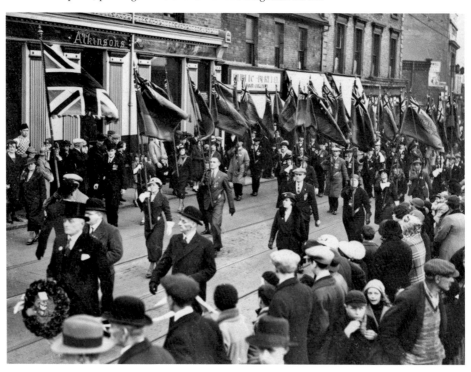

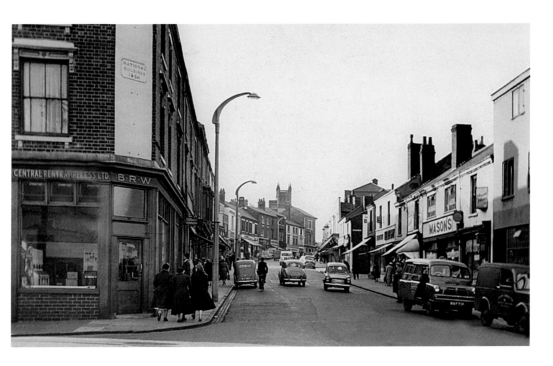

Lower Birmingham Street

In 1956 the 'Low Town' end of Birmingham Street offered a wide range of shops. At this time, we still listened to 'the wireless', as the British Relay Wireless shop on the left confirms, and Ronald Mason Ltd opposite also sold 'radio apparatus'. Beyond Mason's were Toyland, The Boot Supply, Singer Sewing Machines, and Fads the Tailors Ltd. The BRW shop hides Norgrove's cycles, Robinson's bakery, Key's stationery, W. K. Adams & Sons Ltd (drapers), Moyle & Adams grocers, West Bromwich Building Society, the Gas showroom and F. W. Woolworth. By 2000, the buildings on the left had become a car park and part of Oldbury ring road. Although many of the old buildings remain, none of the original businesses from the 1950s is still trading.

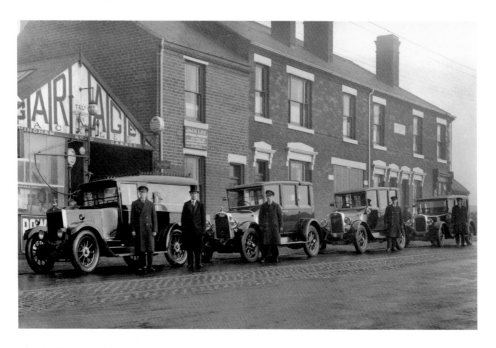

Birmingham Road

Birmingham Street ran into Birmingham Road, where the funeral cars of Jack Lee and Sons are lined up outside their premises at No. 38 in the late 1930s. The firm is now part of Hamer Lee in Birmingham Street.

Today, the road is far too busy for such a line up, and the traffic is only stationary when it tails back from the traffic lights under the motorway bridge. The garage, Jack Lee's offices, and the single-track tram lines have long gone. The old corner shop now sells fish and chips, and the other buildings are occupied by a social club and a restaurant. The date-stone records that 'Ryburgh Buildings' was erected in 1890.

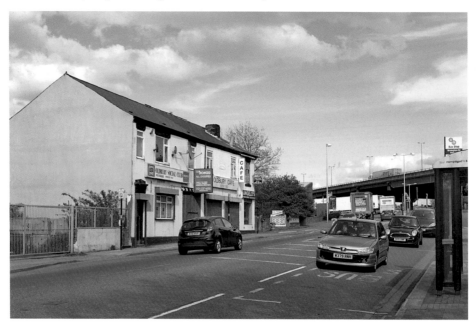

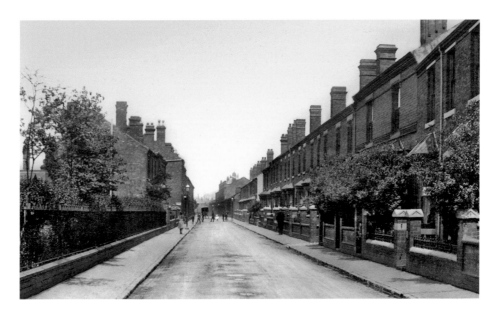

Broadwell

Broadwell Road has changed out of all recognition since the top picture was taken around 1910. The houses have all gone, and Broadwell Park on the left, which was once largely an open sports area, is now heavily planted with shrubs and trees. The houses on the right obscure the Oldbury Carriage Works but its offices, dating from the 1850s, are just visible at the end of the houses. The Carriage Works closed in the 1930s, and was bought by Tube Investments. They moved several of their businesses on to the site, creating their 'Broadwell Works'. One of their companies, Metal Sections, moved there after the Second World War, and, as Metsec Ltd, part of the Austrian Company Voestalpine, they are now the main firm occupying the site.

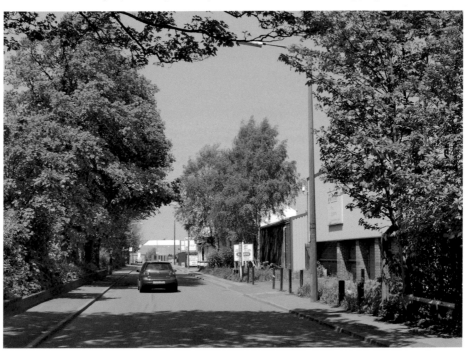

Broadwell Park

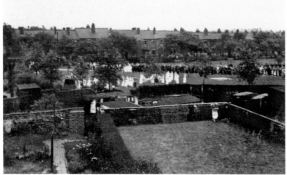

The park, between Flash Brook and Broadwell Road, was given by W. A. Albright in the 1890s as a fully equipped recreation ground with swings, a climbing frame, and other equipment. The above picture shows the 'Broadwell' telephone exchange on the left, and the technical school disused and awaiting demolition in 2000. The park had a large central grassy area suitable for events, such as a Corpus Christi parade from St Francis Xavier Church in the 1950s. Flash Brook is at the end of the gardens with the houses of Broadwell Road in the distance. Recently, the park has been more heavily planted with shrubs, new paths made, and a new play area built. The picture on the opposite page shows the brook with the park on its right. The bottom of its enclosing wall is made of spent phosphorus retorts from Albright and Wilson.

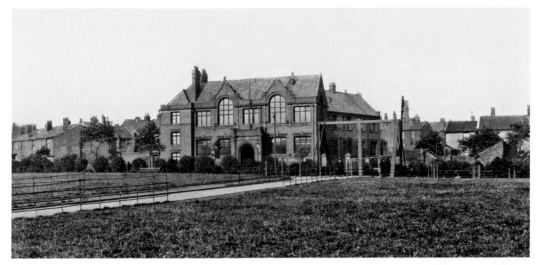

Oldbury Technical School

In 1899 a technical school was opened in Flash Road, facing Broadwell Park, to provide evening classes for workers in Oldbury's industries. A secondary day school followed in 1904, and this moved to Moat Road, Langley, in 1926 as the County High School. The building became home to a Commercial School in 1930, renamed Oldbury Technical School after the Second World War. The park was a convenient place for its pupils to relax. The Technical School moved to Pound Road, Warley, in the 1962. It merged with Langley High School (the old Grammar School) to become Oldbury College of Sport. The original building has been replaced with a housing development, below.

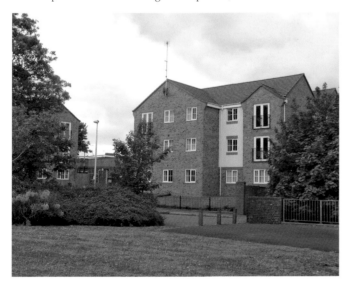

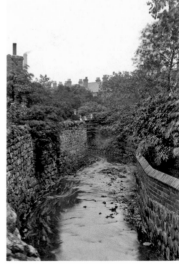

Oldbury Locks Junction I

This peaceful scene shows the junction of the Titford Canal with the old main line from Birmingham to Wolverhampton, and is very different from the picture sixty years ago. Then, the canal was not overshadowed by the M5 motorway, and it was the dock for Thomas Clayton's narrow boats as they collected tar from local gas works for the Midland Tar Distillers, and carried petroleum from Ellesmere Port to the Shell-Mex Depot in Langley. Clayton's wharf is just visible through the bridge, which carries the towpath from the Titford Branch over the main line.

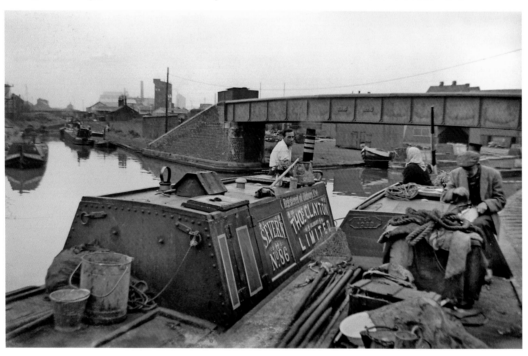

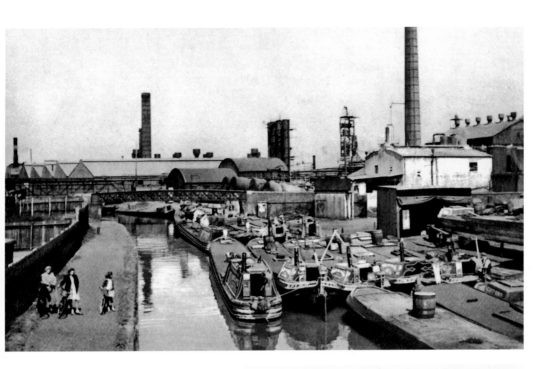

Oldbury Locks Junction II

In the 1950s Thomas Clayton's yard was packed with boats. One is out of the water being repaired on the stocks. The Titford towpath bridge, in an earlier open lattice form, is seen in the distance, and beyond it the foundry of Shotton Brothers and the fractionating towers of Midland Tar Distillers. Thomas Clayton had brought tar to the Springfield Works since late Victorian times, and sited their base close to the works of their most important customer. Nothing remains of the wharf. Petroleum products were taken up the six Oldbury locks on the Titford Canal to the Shell-Mex depot at Station Road, Langley. The middle picture, from the 1920s, shows a petroleum boat being unloaded, with the Langley Maltings in the background. Nowadays, only pleasure craft use the locks, attracted by Birmingham Canal Navigation Society rallies.

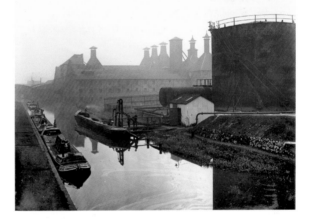

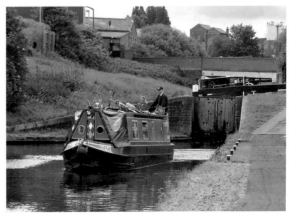

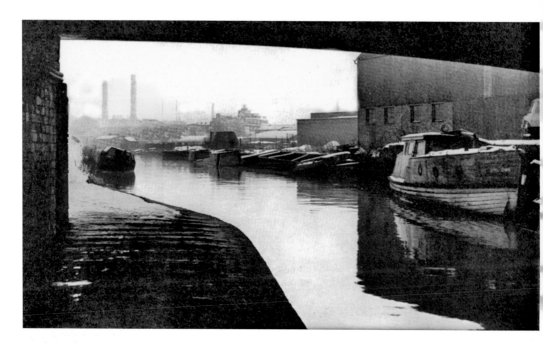

Canal at Whimsey Bridge

The top picture was taken between the wars when the canals were filled with working boats. The distant industry has largely gone and only pleasure craft remain at Valencia Wharf in the modern picture. The industrial site to the right is now a garden and aquatic centre. The old loop of Brindley's original canal, which joined under the towpath bridge just beyond the boat on the left, has been filled in. Even Whimsey Bridge has been rebuilt, widened to take a dual carriageway.

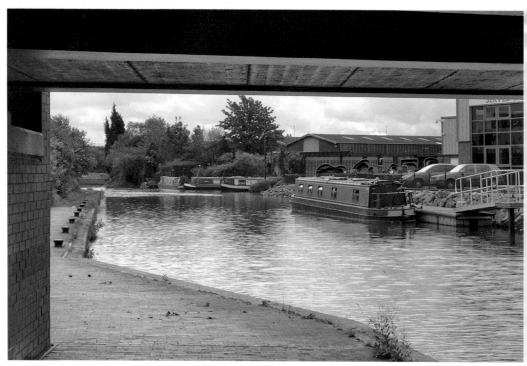

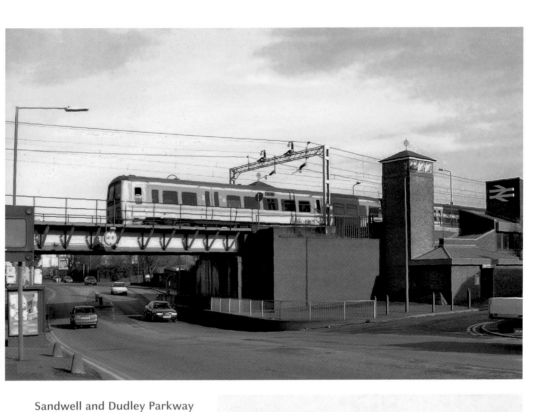

Sandwell and Dudley Parkway

This is a strange modern name for a station that was always known as 'Oldbury and Bromford Lane' since 1853, when it opened as part of the Birmingham, Wolverhampton and Stour Valley Railway. Soon afterwards the line became part of the London & North Western Railway.

In 1923 it was absorbed into the London Midland and Scottish Railway, and was an LMS station when the bridge was replaced in the 1930s. The feat was achieved over a weekend without stopping the trains, and clearly provided entertainment for the locals. The bottom picture shows the widened bridge, which appears to be the same one pictured in 2001. The line was electrified in the mid-1960s.

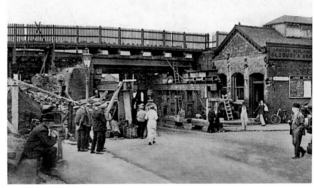

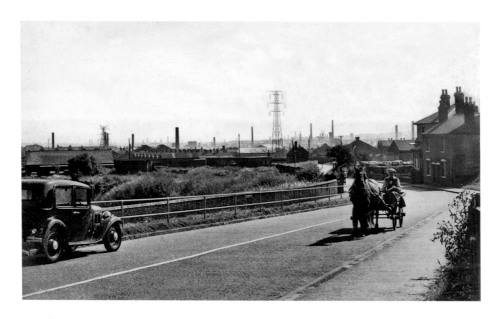

Portway Road

Portway Road leads from Oldbury towards the Rowley Hills. The name 'Portway' usually signifies an important ancient road, frequently a Roman one, and the hamlet of Portway on the Rowley Hills may have a Roman connection. The top picture shows the many factory chimneys that graced Oldbury's skyline between the wars. The wall to the left of the road encloses one of the many marl holes to be found in the Rounds Green area. This one served Shidas Lane brickworks. Some residual buildings of the brick works are seen across the marl hole, and, beyond them, part of Accles and Pollock's tube works. The marl hole has been filled in, and is the site of Sandwell Council's yard and recycling centre, on the left of the lower picture. The scene is otherwise very similar, with small industrial operations in the area, but the road is much busier.

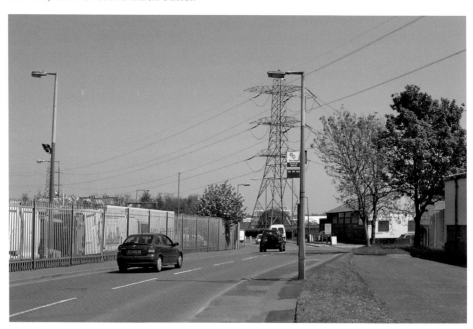

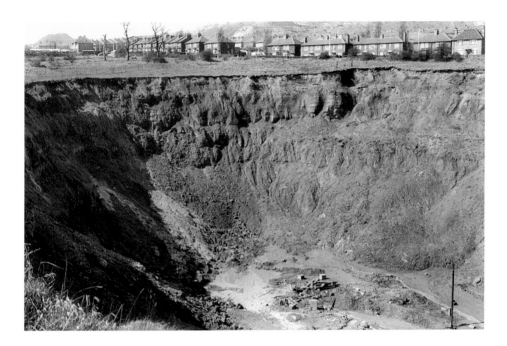

Pratt's Marl Hole

Oldbury was surrounded by marl holes by the end of the Victorian era, and many of them remained until well after the Second World War as deep pools of stagnant water. The last to be filled in was that of the Portway Brickworks, between Shidas Lane and Portway Road in 2011. The last marl hole to be worked served the New Century Brickworks in Newbury Lane, which had been started by Joseph W. D. Pratt in 1900. The top picture shows what an immense hole it had become by the 1950s. The brickyard was demolished, the marl hole filled in, and the ground levelled around 1990, although manufacture of bricks had stopped earlier. The site is a grassy open space today, with all traces of its former use gone, except for uneven ground where the manufacturing plant once stood. Lettered bricks can still be unearthed from the manufacturing site. PL indicates Pratt's Limited and LBC the London Brick Co.

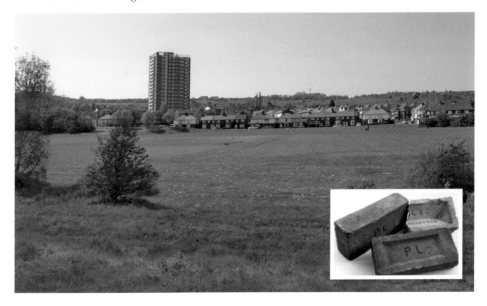

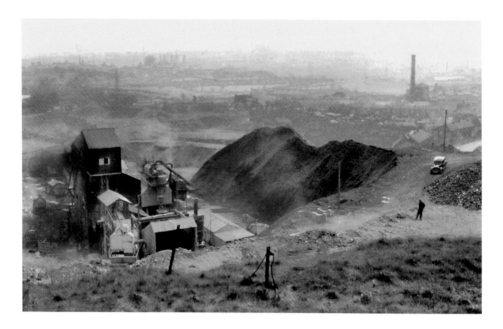

Bury Hill I

Bury Hill is an outcrop from the Rowley Hills which was the scene of quarrying until the second half of the twentieth century. The top picture shows Blue Rock Quarry in the 1960s. In the distance is the chimney of Pratt's brickyard on the right. Almost lost in the haze, the chemical works and towers of Albright and Wilson's phosphorus works can be seen to the left.

Today, it is hard to locate the site of the quarry among the scars cut into the face of the hill and the shrubs that have taken over. The landmarks have vanished: the chimney and brickworks have gone, and Albright's towers have been dismantled. On the left of the picture is Rounds Green Methodist Church at the crossing of the A4123 with Portway Road and Newbury Lane.

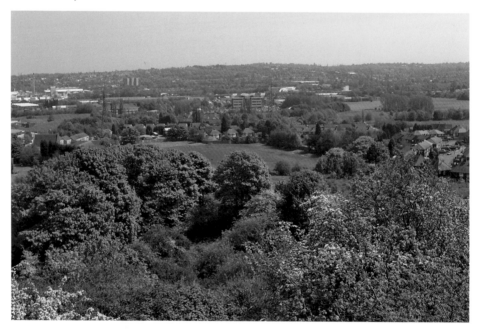

Bury Hill II

To mark the Diamond Jubilee of Queen Victoria in 1897, the local MP John W. Wilson laid out part of Bury Hill as a park and gave it to the people of Oldbury. His wife gave the 'Florence Lodge' on the right of the picture. The people of Rounds Green donated two hundred trees and some benches, and it soon proved a popular spot for local people to climb out of the smoke of Oldbury into cleaner air.

The park was badly affected by the construction of the A4123 in 1926. This cut through the lower part, removing most of the flower beds and making it necessary to re-site the lodge. The house in the centre of the upper picture is the white house in the lower.

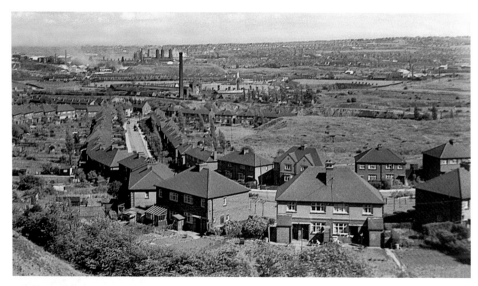

Lion Farm Estate I

The first council houses on the lower slopes of the Rowley Hills were erected before the Second World War in Ivy House Road and Wallace Road. The top picture shows Wallace Road in the 1960s. Pratt's brickyard and its marl hole can be seen beyond the houses. No. 38 Wallace Road, the 1,000th house built by direct labour by Oldbury Council, was opened in 1933 by Cllr Giles.

In the 1950s work started on a new estate between Newbury Lane and Throne Road. The estate was almost complete when the bottom picture was taken in the late 1970s. It clearly shows the high-rise flats which were a feature of the estate, and many of which have now been demolished.

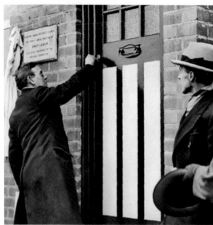

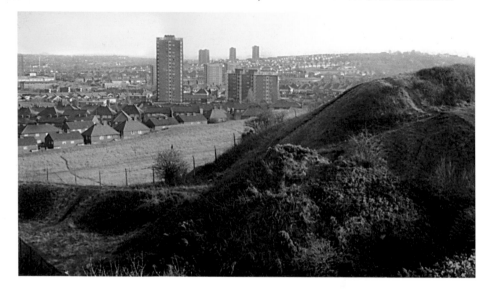

Lion Farm Estate II

The new development was called Lion Farm Estate, to the great annoyance of Mr Skidmore since most of the land was that of his Throne Farm. Oldbury Council was engaged in 'slum clearance', and many of the people who moved on to the estate came from poor housing in Rounds Green or the centre of Oldbury. Rounds Green had been served by the church of St James, opened in 1892 as part of Langley parish. A separate Rounds Green parish was formed in 1905 with St James as the parish church and the Church of the Good Shepherd in Birchfield Lane as a chapel of ease. In 1964 St James's Church was moved to a new building at the heart of Lion Farm Estate. Appropriately, the distinctive steeple cross was made at Accles and Pollock in Rounds Green, where many of the people on the estate worked.

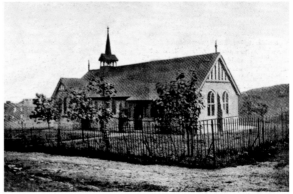

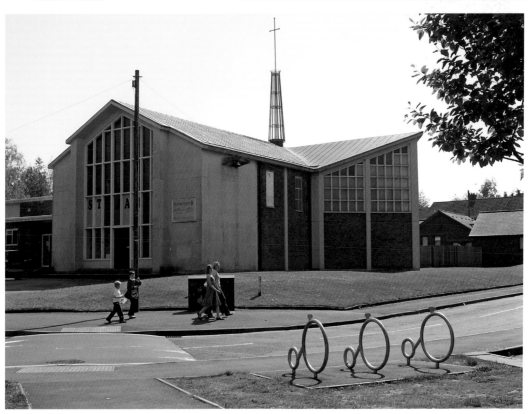

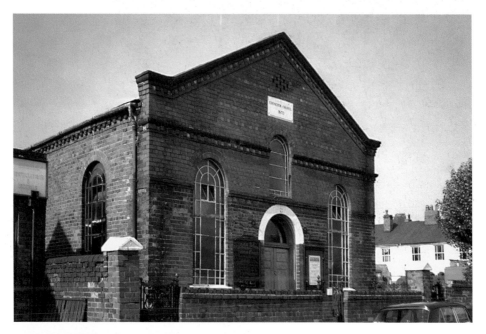

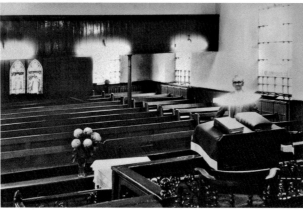

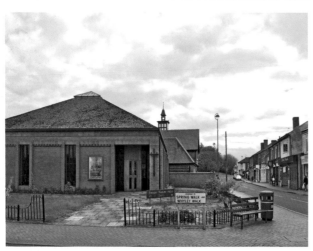

Ebenezer Wesleyan Reform Chapel

The Wesleyan Reform movement in Oldbury started with a small group of people meeting in a cottage in 1865. After great struggles they opened the Ebenezer Wesleyan Reform Chapel in Hunt Street ten years later, and added a Sunday School room in 1891. The building was demolished in the redevelopment of Oldbury town centre in the 1970s, one of several Victorian chapels lost at that time. The exterior and interior pictures were taken shortly before the closure. The Ebenezer Chapel moved from Oldbury to a site on the corner of Langley High Street and Spring Street, where it is still active. It is the only remaining place of worship in Langley 'village', the next nearest being Zion United Reformed Church at Langley Green.

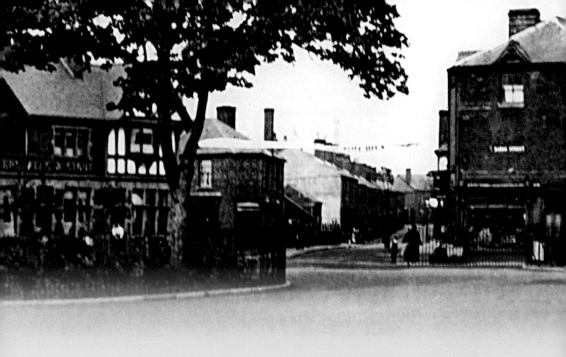

CHAPTER 2

Langley, Langley Green & Rood End

The original settlement of 'Langley' was at Langley Green on an ancient route between Halesowen and Smethwick. The previous page shows the scene from the car park of the Old Cross Inn, which may well have been the village green for the hamlet. The first church in the area grew from the visit of a Moravian preacher in about 1775, who addressed the villagers under a large tree on the 'green'. After meeting in various hired buildings, the faithful opened Zion Independent Chapel, which survives, several buildings later, as Zion United Reformed Church. The village was completed by a few scattered cottages, the Old Cross Inn, Langley Hall and its farm, and Langley Mill across the fields at the end of Mill Lane. The rest was agricultural land with a few nail makers plying their trade at home.

Rood End was also an old hamlet, and probably took its name from a rood cross somewhere near the settlement. Like Langley Green, it consisted of scattered cottages collected around an inn, the Bell Hotel, which became a coaching establishment a short distance from the Birmingham to Dudley turnpike.

Coal mining had moved into the fields between Oldbury and Langley around 1800, but a more significant change occurred in the 1830s when the Titford Canal was cut from the canal at Oldbury to transport coal from the mines close to the Rowley Hills. In 1835 the chemical industry started with Chance Brothers opening a chemical works to supply their glass making business at Smethwick. These industries brought opportunities for employment that drew people into the area, with a demand for houses and better facilities.

Around 1850 part of Park House Farm land was sold for houses and the erection of a new church, correctly called 'Trinity Church, Langley', but always known as 'Holy Trinity'. When this was consecrated in 1852, Langley became a parish, and the new 'village' of Langley overtook Langley Green in importance as it acquired more houses, shops and public houses. Various Methodist chapels were built, and schools were opened by them and by the Anglicans. By the end of the nineteenth century, Holy Trinity was too small for the population and the larger St Michael and All Angels opened at Langley Green in 1890. This became the parish church with Holy Trinity as a chapel of ease.

Social developments improved the quality of life, with parks at Langley and Barnford Hill, sport clubs, societies and the Langley Prize Band, which, as its name suggests, was very successful. Activities at the Langley Institute included a literary and debating society, the first library in Langley (superseded by the public library in 1909), concerts, dances, 'Pleasant Sunday Afternoon' meetings, and the first cinema. This cinema did not last into the talkie era, but the up-market Regent Cinema in Crosswells Road continued until around 1970.

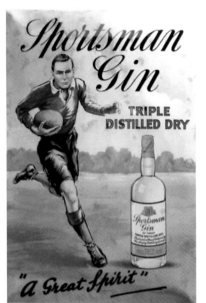

The railway arrived in 1870 with Oldbury and Langley Green station to serve both Langley and Langley Green. This attracted more industries, with forges, foundries, brickyards and breweries well established by 1900, and the manufacture of pens, bottles, sweets and plastics added by the Second World War. In the 1960s many of these industries started to decline, being taken over, sold-off, down-sized and finally closed.

In the 1970s and '80s, both Langley and Langley Green were redeveloped, their street patterns changed, and new houses and shops built. Rood End has survived largely intact, although, like most places, its shops have a different character today. Between the wars it had seen extensive housing development and the loss of its remaining fields.

Not many products carried Langley's name round the world, but the label of Sportsman's Gin says it was brewed by The Langley Distillery Limited. Gin is still distilled there today.

Langley Green Zion

The top picture is doubtless the oldest in the book, and shows the second chapel building just before its demolition in 1877. The gentleman in the middle is Revd Clement Pass, an Oldbury clock maker and part-time minister from 1845 to 1889. The middle picture shows the interior of the third church which was demolished to make way for the present building. It had a fine organ, a gallery and large central pulpit, typical of non-conformist chapels in the area. The fellowship has born witness for over 200 years on the same site, making it the oldest church still operating continuously in Oldbury. The lower picture shows part of the church buildings. To the left is a recently made garden built around a large wooden cross and facing Langley Green Road. The current church building is largely hidden behind the central trees.

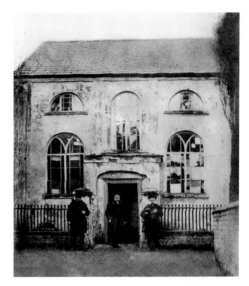

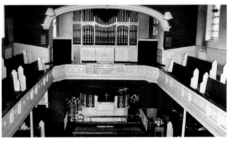

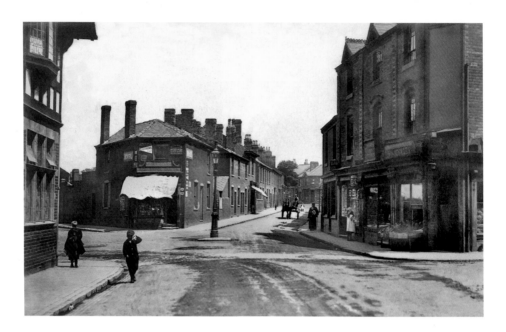

Five Ways, Langley Green

For centuries Langley Green was a hamlet at the junction of the road from Halesowen to Smethwick with the road to Oldbury, to the left at the Royal Oak. However, it started to be built up in the last quarter of the nineteenth century, when Henry Street, to the left of the shop with the blind, was cut in the 1880s. By 1900, Barrs Street, to the right, made the junction a 'five ways'. With the changes in the 1970s, the five ways vanished again as Henry Street and Langley Road, with the horse and cart, were replaced by New Henry Street, and Barrs Street closed off to traffic.

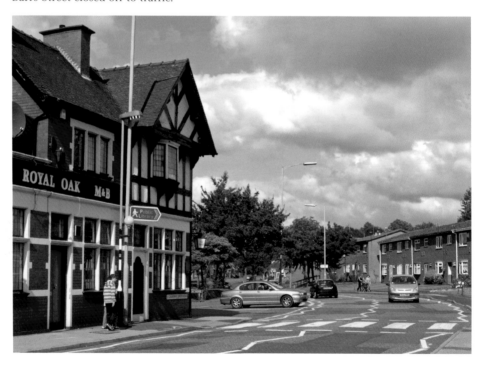

Langley Road

No-one who is under forty will remember Langley Road as it used to be, a continuous run of houses and shops with little, if any, frontage. Both the old pictures date from the early 1970s, just before the redevelopment of Langley Green. They show little change from the 1910 picture opposite. The white shop in the centre of the top picture was Young's Store, selling seed, corn, and pet supplies. Next came the post office and a carpet shop, and in the distance three of the shops owned by the Sherwood family, a fish shop, a confectioner's, and a shoe shop. The middle picture shows Hadley's ironmonger's on the corner opposite Farm Road, and William Jackson's builders' workshop in the distance. All this was swept away in the late 1970s to leave a quieter, more open, housing area in what remains of Langley Road. The lower picture was taken from the same place as the middle one.

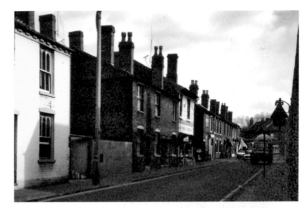

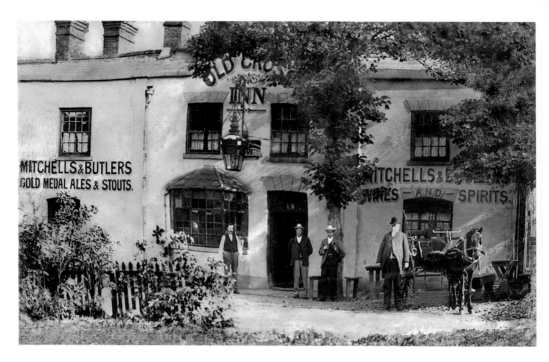

The Old Cross Inn

This old inn stood by the village green at Langley Green on the road from Blackheath to Smethwick. The old picture shows the building in the early 1900s, when Mr Marygold was one of the regulars and arrived in his pony and trap. Today, the building is the same, but the patrons arrive by car, and what remains of the green is now the car park for the public house.

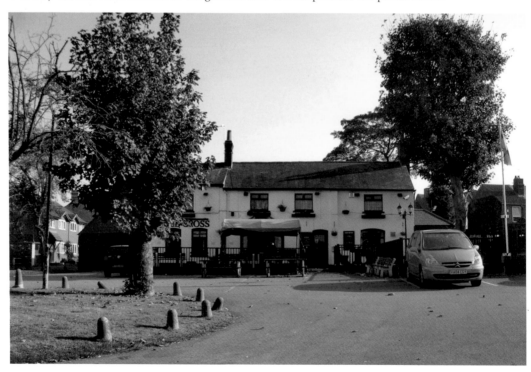

Barrs Street

Terraces of Victorian houses characterised Langley Green, which expanded rapidly at the end of the nineteenth century. They remain in Barrs Street, shown here, and the adjoining Cross Street, Ethel Street and Farm Road. Such streets could be closed off easily for events such as coronation and jubilee parties.

In the distance is Langley Library, a Carnegie building opened in 1909, and little changed externally to this day. The arrangements inside are very different, however, where a relaxed atmosphere and wide range of activities replace the original newspaper room and closed-shelf system for books. Borrowers did not browse the actual books, but chose from a catalogue and informed the librarians, who collected the books and presented them to the borrower through a hatch.

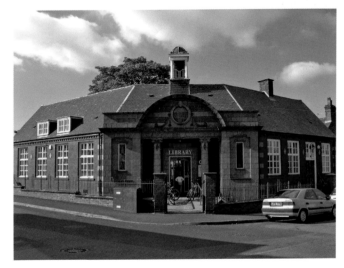

49

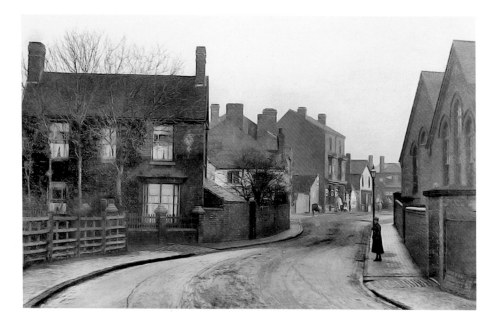

Langley Green

This bottleneck, around cottages at 13 & 15 Causeway Green Road, would certainly slow today's rush hour traffic, but, fortunately, it was removed around 1930. The road was widened and a new house erected further back by William Gem. The building on the right is St Michael's Secondary School, opened in 1893 and demolished in 1973, when the school moved to a new site in Throne Road. The white building in the distance is the old Royal Oak, which was rebuilt in the early 1900s.

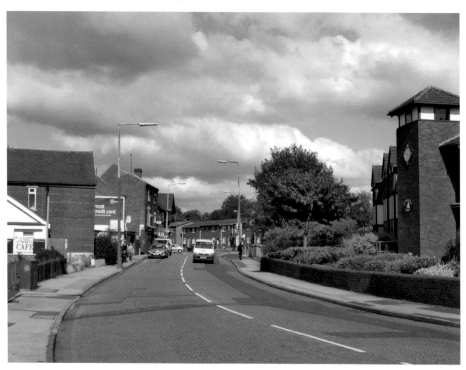

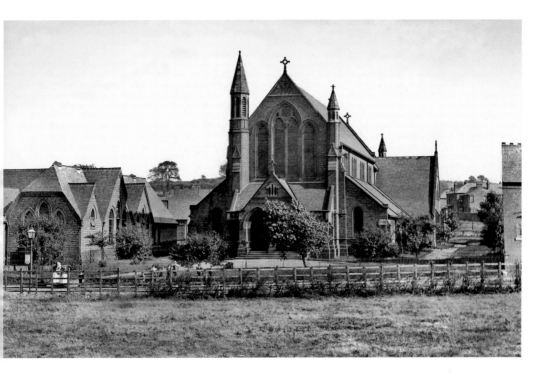

St Michael and All Angels Church, Langley Green

St Michael's church was dedicated in 1890 by the Bishop of Worcester, replacing the smaller Trinity Church as the parish church for Langley. The last service was held in July 2007, and, six years on, it still stands empty awaiting another use. The lower picture shows those who attended a children's service in 1921, with the school building behind.

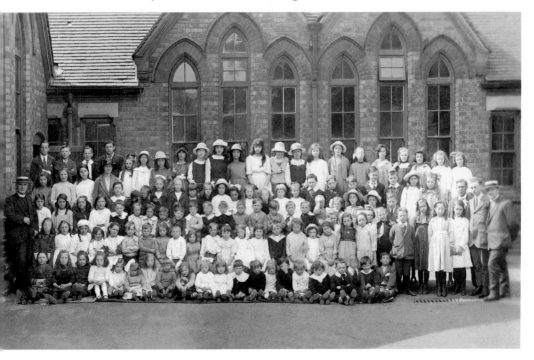

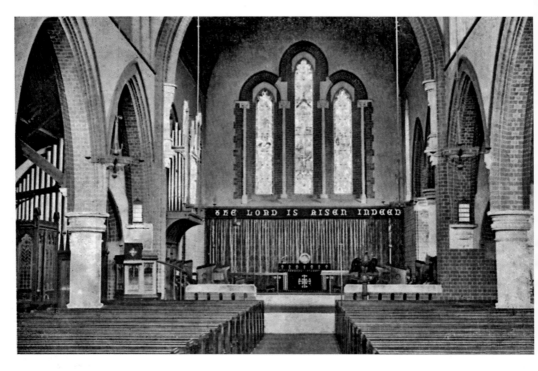

St Michael and All Angels Church, Interior I

The original interior, photographed in 1900, differs only in detail from that in 2006, just before the closure of the church. The most striking change is the wooden panelling behind the altar, installed soon after the old picture was taken.

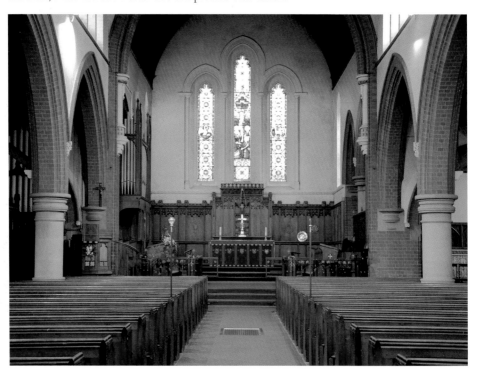

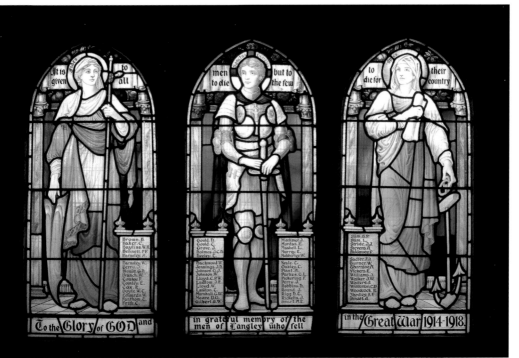

The stained glass windows contain the following text:

"It is given to all" — "men to die but to the few" — "to die for their country"

Column lists of names:

Brown, B.
Baker, C.
Bayliss, W.R.
Bennett, P.F.
Barnsley, A.

Barnsley, W.
Berry, J.
Blewitt, G.H.
Branch, W.
Cowley, F.
Comley, E.
Cox, E.
Doyle, W.C.
Edwards, W.
Fanthom, C.
Frith, C.

Gould, D.
Gould, C.
Grove, J.
Holmes, J.C.H.
Heeley, C.

Backwood, W.
Jennings, J.B.
Johnson, G.J.
Johnson, W.
Lloyd, C.P.W.
Ludlow, J.E.
Lloyd, W.
Laston, C.
Marshall, G.W.
Moore, D.G.
Gilbert, G.W.

Mortimer, J.
Mordan, E.
Maskell, E.
Murrey, E.
Mobberley, W.

Neale, C.
Oakley, C.
Plant, A.
Parkes, G.L.
Pickering, F.
Perry, J.
Robbins, D.
Round, J.
Rigg, D.E.
Ricketts, J.
Smart, A.E.

Slim, G.F.
Slim, L.
Stride, J.J.
Stevens, A.
Biddaway, F.

Sadler, J.J.
Turner, W.
Thornloe, H.
Vickers, E.
Walker, J.W.
Watters, J.
Winterton, C.D.
Woodcock, A.
Yardley, S.F.F.
Smart, A.

"To the Glory of GOD and" — "in grateful memory of the men of Langley who fell" — "in the Great War 1914-1918."

St Michael and All Angels Church, Interior II

St Michael's has some important stained glass windows, including the memorial window for the men of Langley who fell in the Great War. A window by Thomas William Camm of Smethwick, showing Christ with the children, is a memorial to Gladys Pryor, who died aged twelve. She was the daughter of the first vicar to serve at St Michael's. Her image is included as the child upon whose head Christ's hand rests. The main east window, given by Sir Alexander Macomb Chance, shows the crucifixion. The future of all these windows is a matter of concern.

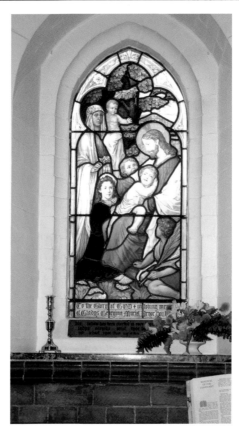

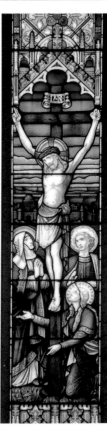

Barnford Hill Park I

The park was the gift of G. S. Albright during the First World War. The shelter and pavilion, shown in 1935, included changing rooms for the footballers and cricketers who used the park. In later years the open end of the shelter became an office for the resident park keepers who issued tickets for the tennis, putting and bowls. The pavilion tower housed the bell rung for the closing of the park each evening. Pudding rock, a conglomerate outcrop visible on the left skyline of the old picture, is the 'hill' in the park's name.

In 2012, the tennis courts are a car park, the putting green is a wood and the bowling green has a hedge maze in it – no need for the pavilion to issue tickets, and it has been replaced by modern changing rooms.

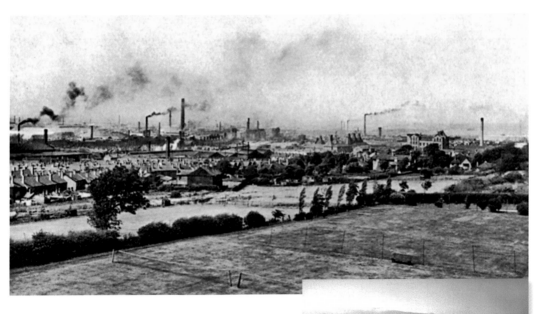

Barnford Hill Park II

Pudding Rock in the centre of Barnford Hill Park gave a panorama across Langley and Oldbury. The 1920s picture is bristling with smoking chimneys arising from the iron and chemical industries. The large building to the right is Showell's Brewery. In the middle picture from the 1950s there are less chimneys, but the clean air acts have not had their full effect. The Sons of Rest building has been added to the park, and the grass tennis courts have become a putting green. The view is now largely obscured by the wood that has replaced the putting green, with just the top of the Rowley Hills visible.

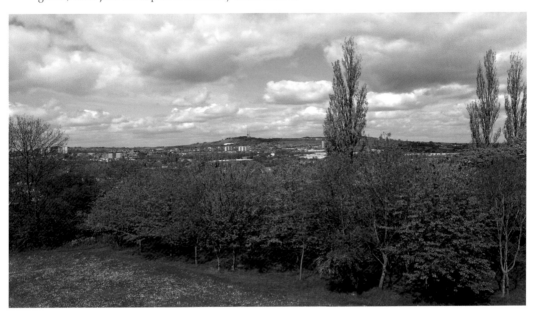

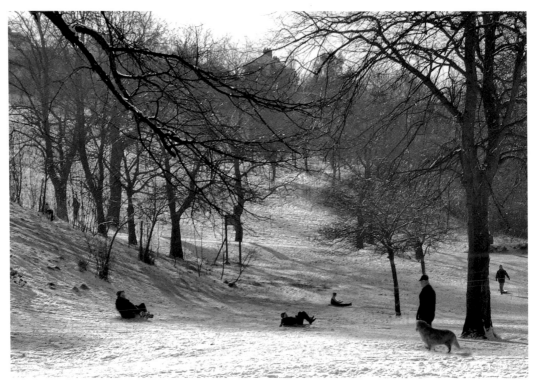

Games at Barnford Hill Park
Local parks have long provided an outlet for people to enjoy themselves and let off their high spirits. The children's games were captured in 1926, when the park was less than ten years old. Warley Institutional Church cricket team was one of the clubs using the park regularly in 1950. Opportunities for sledging get fewer as the planet warms up, but full advantage was being taken of the snow in 2000.

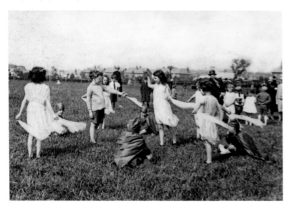

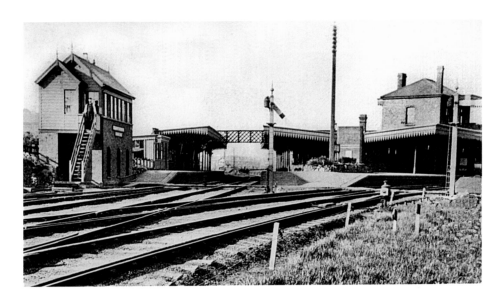

The Old Signal Box

This picture dates from around 1905 and shows the junction of the main line to Stourbridge and the south-west, with the branch line to Oldbury Town joining from the right at Oldbury and Langley Green Station. The signal box at the level crossings in Station Road is just visible under the bridge. Shortly after the picture was taken, the signal box on the left was replaced by one on the opposite platform, which had better visibility of traffic on the two lines. The redundant signal box found employment as a garage and shed at a house in Grosvenor Road, Causeway Green, and is still in use.

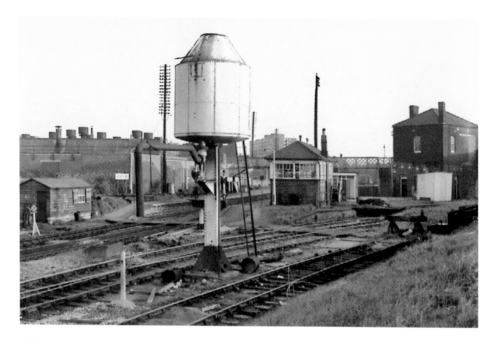

Oldbury and Langley Green Station I

By the 1970s the layout was little changed, except for the addition of a typical GWR water tower and the removal of the awnings over the platforms. The line to Oldbury Town now only carried goods traffic to the chemical works of Albright and Wilson. All the old buildings, including the booking office on the bridge, have been replaced, and the lines to Oldbury Town removed. The distant flats remain, but the factory site of M. Myers & Sons, who made pens and office equipment, is now a housing estate. In the distance are Langley Maltings, a local landmark on the side of the canal, which were badly damaged by fire in 2009.

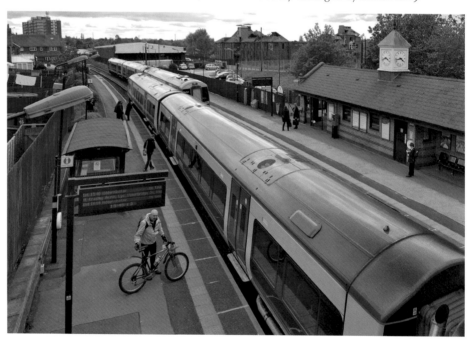

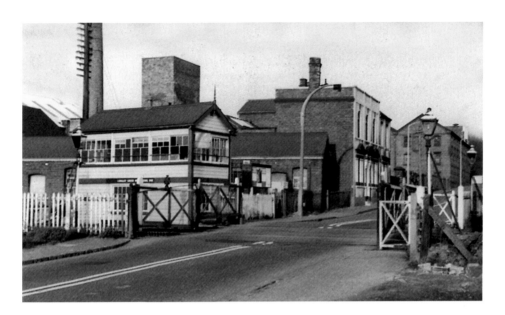

Oldbury and Langley Green Station II

The old-style crossing gates were operated from the Langley Green West Signal Box. They also had small gates giving pedestrians a little longer to cross after the main gates had stopped the traffic, before they too were locked by the signalman. The low building behind the signal box was originally the stable block for the horses of the GWR. During the rail strike in 1911 a crowd blocked the crossings, preventing the gates being opened, and would not disperse until the Army arrived with fixed bayonets! The signal box has been removed and the crossing now has barriers, with no concessions to pedestrians! In the background are the remaining buildings of Crosswells Brewery and Langley Distillery Company, which still produces gin.

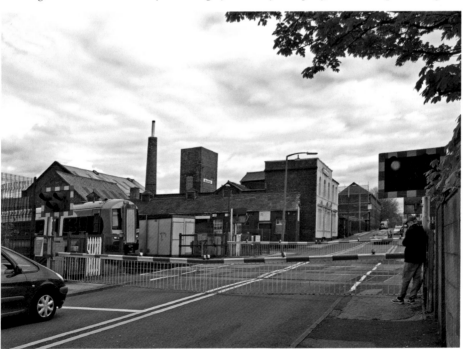

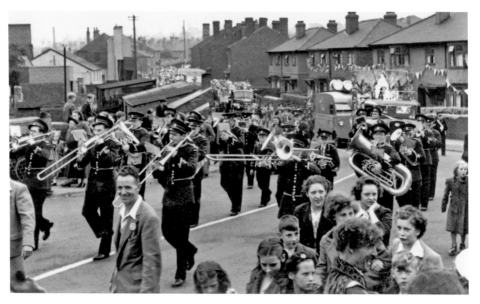

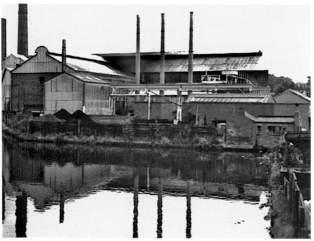

Uncle Ben's Bridge

Langley Carnival was an annual event after the Second World War, and the upper picture shows the procession in 1953 with the Carnival Queen's float and the Langley Prize Band leading them from Langley Green, over Uncle Ben's Bridge, and down the High Street to the park in Langley. The band no longer marches and is now solely a concert band.

In the background is Slade's coal yard and wharf, and beyond that a row of houses, Langley Forge and Hughes-Johnson Stampings. These are shown in the middle picture. All of these have been demolished, the buildings of Langley Forge lasting just into 2012. The picture below shows the same area, now open and awaiting development. The only notable building is Alfred Gunn House in Thompson Road, Langley's only high-rise flats.

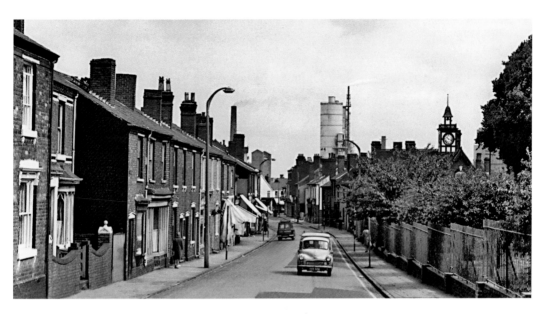

Langley High Street

Langley High Street was originally called Pit Lane because it led to a colliery off Clay Lane. Since it was first built-up in the 1850s, it has always had a mixture of shops and houses. The houses have all been rebuilt now, but most of the shops on the left side of the road remain after being renovated. The old picture shows the street just before the redevelopment. The tall chimneys and chemical plant of Albright & Wilson's phosphorus works dominated the view at the end of the road, but most have been replaced. The company is now part of the Rhodia Division of the Belgian company, Solvay and Cie.

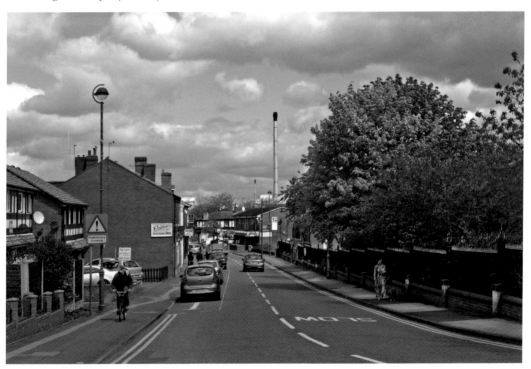

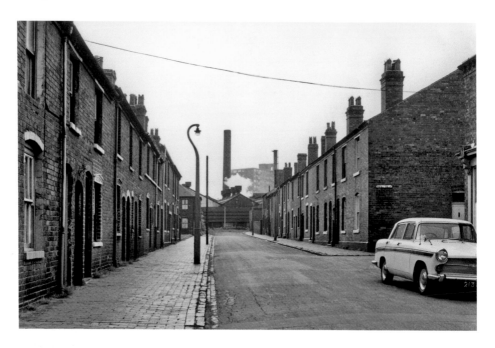

Whyley Street and Whyley Walk

Whyley Street, shown here in 1970, is typical of the terraced housing built at the end of the Victorian era for working class families. The front doors opened straight on to the blue brick pavements with no front gardens. The street ran from Five Ways to the towpath of the Titford Canal with Hughes-Johnson's forge on the far side. All these houses were swept away around 1980, and the new build, Whyley Walk, has a very different feel with grass areas and trees between the houses and limited access for cars.

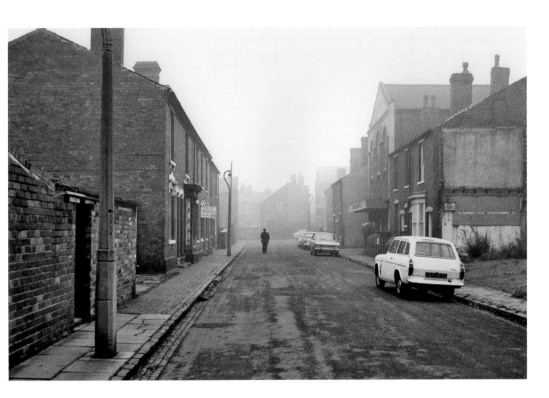

Spring Street

Spring Street was one of the first new roads to be made in Langley when it was being developed in the 1850s. It ran between High Street and Whyley Street, through Spring Meadow, which was named after its wet ground and natural springs. A Primitive Methodist Chapel opened in Langley soon afterwards, and the building shown below opened in 1871. When this closed in the 1950s, it was taken over by the Oldbury Repertory Players and, therefore, saved from the bulldozers when the houses were cleared around it. The theatre, called the Barlow Playhouse, has been extended since the top picture was taken in 1960, and now has a more open setting. The chapel on the right of the current picture is the Ebenezer Wesleyan Reform Chapel, a newcomer to the scene.

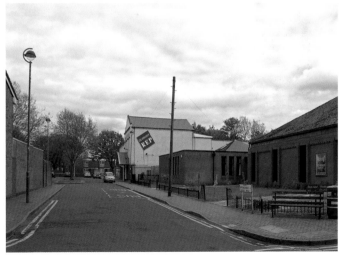

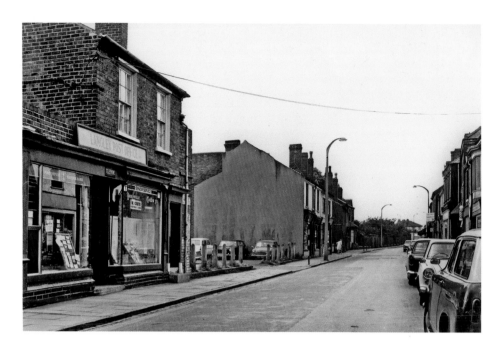

High Street, Langley

When Langley was redeveloped, the High Street lost two significant buildings: the Langley Institute and the post office. Just before the First World War, Langley Post Office was started with William Swain as postmaster, in a building converted from a public house, the Fountain Inn. In 1974, shortly after the picture was taken, it was the scene of a murder when the postmaster, Sydney Grayland, was killed and his wife severely injured by Dennis Neilson, the 'Black Panther'. It did not re-open until a new post office was included in the rebuilt shops. Langley Institute is the prominent building just beyond the barber's sign in the shops on the right.

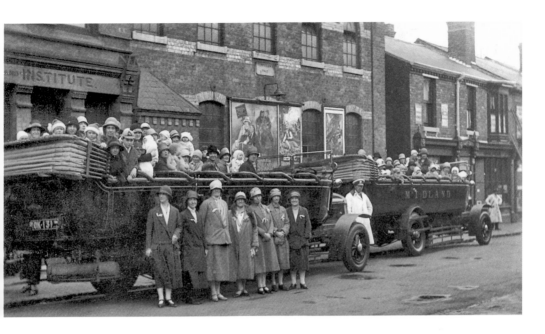

Langley Institute

The Institute, built in 1877 as a Temperance Hall, became the focus of Langley's social life. It provided the first library, a debating society, a venue for concerts and meetings, a cinema in the silent era, the first home for the Oldbury Repertory Players, and a convenient place to gather for outings. The picture was taken around 1920 when the main hall was a cinema. It was demolished in 1972, and replaced by a new furniture and radio shop for A. E. Watkins, whose premises had also been demolished. It is now another supermarket!

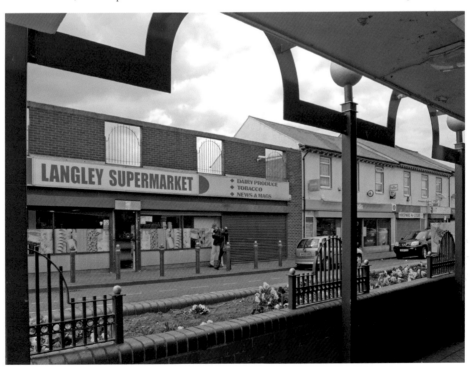

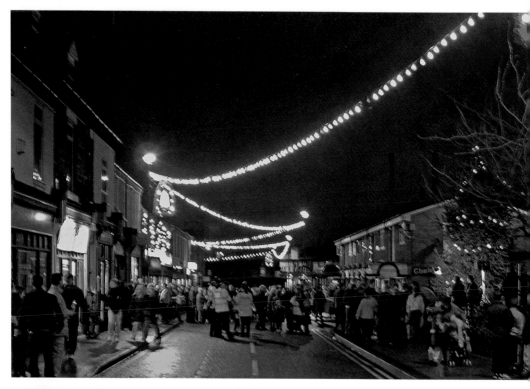

Langley Lights

Towards the end of November each year festive lights in the High Street were provided by Langley Traders' Association. The shops stay open late, and everyone turns out for the fun fair, fireworks and entertainment when they are switched on. These pictures date from 2003, when it was not deemed too much of a safety risk to string bulbs across the street: not so now, when there are no overhead lights, just a few on the lampposts.

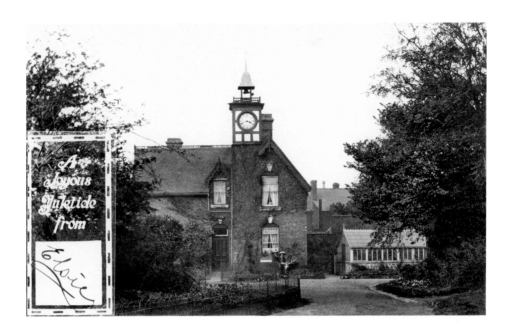

Langley Park

This picture postcard from 1912 has been changed to a Christmas card by adding the greeting on the left. It shows Langley Park, which was given by Arthur Albright in 1886 because, even then, he was concerned at the rate at which open spaces were being replaced by houses. He provided a house for the park keeper, and greenhouses to grow the many flowers required for the bedding. The park is more open now, with fewer flower beds, a small car park and a children's playground. The house has become a community centre with an extension where the greenhouses once stood.

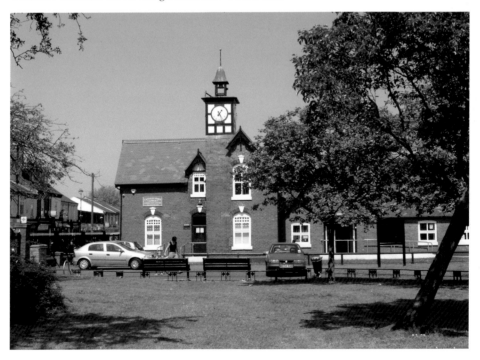

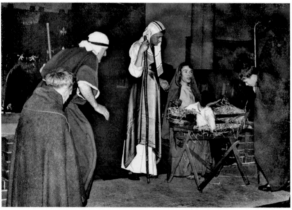

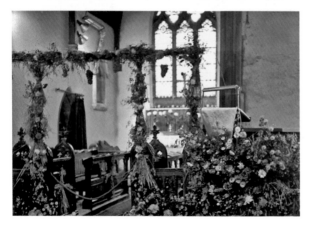

Trinity Church, Langley

When Langley 'village' was first being developed, part of the fields of Park House Farm was given for the erection of a church. Thus, in 1852 'Trinity Church, Langley', or 'Holy Trinity' as it was locally known, was consecrated as the parish church for Langley. The church was stone-built, with a small graveyard and surrounded by roads. When the larger St Michael's Church was opened in 1881 as the new parish church, Holy Trinity became a chapel of ease, but remained the preferred place of worship for many Langley people. The main picture dates from the 1950s, and the one below shows a nativity play at this time. The church was closed in 1960, and the bottom picture shows the last harvest festival to be held there. The closure caused great bitterness and distress among its congregation, but their objections were ignored and the building was demolished eight years later. All that remains now is a green island on the approach from Oldbury to Langley.

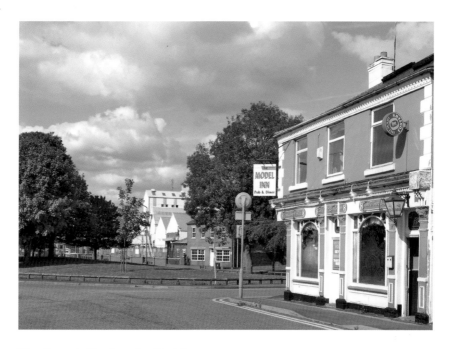

The Queen's Head or the Model

The green space that once contained Holy Trinity is overlooked by the entrance to the phosphorus works of Albright & Wilson, now the Rhodia Division of Solvay and Cie, on the far side, and by the Model Inn in Titford Road. The proper name for the inn is the Queen's Head, as shown in the 1970 picture below. However, it was always known locally as 'The Model' because the glass panes in the windows advertised 'Smith's Aston Ales – Aston Model Brewery'. The window on the right of the 2009 picture still contains an original pane. The name of the inn was changed some years ago.

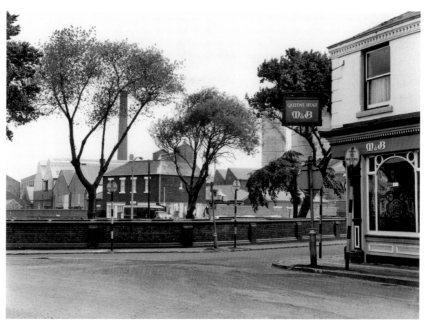

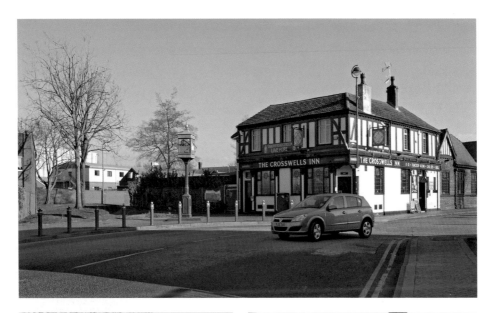

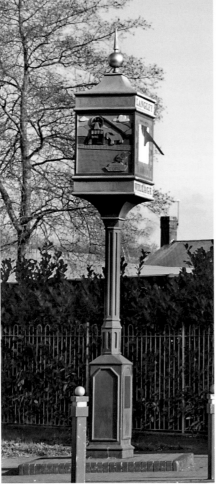

'Five Ways', Langley I

Like Langley Green, Langley had a place where five roads met until the redevelopments of the 1970s and '80s reduced the old 'Five Ways' to a single through road with a sharp bend between High Street and Broad Street. The former shops of Trinity Street and Station Road were lost. The Crosswells Inn was unaffected by the changes, and remains much the same as it ever was. It took its name from Showell's Crosswells Brewery and sold their ales. By 1930, when the licensee, Albert Cottrell, stood proudly outside, Allsopps had taken over the brewery, and the inn then offered their Burton Ales. The centre of the old junction is marked by a 'sundial tower', designed by the pupils of Langley Primary School and erected in 1997, when further development of the High Street was finished.

'Five Ways', Langley II

Two of the roads which met at 'Five Ways' are Station Road, above, and Trinity Street, both photographed in the 1970s. The closed-up shop on the corner had been the local Co-op, started by the Soho Society and taken over by Birmingham Co-operative Society in the 1920s. The green space in the current picture is on the line of Station Road. The slate-coloured building is the former Lloyds Bank, which closed around 2000.

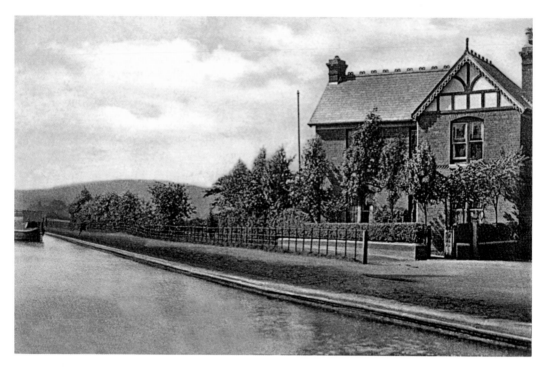

Titford Canal

The top view, taken around 1905, shows the Titford Canal, opened in 1837, looking towards Tiford Pool from Uncle Ben's Bridge. The scene is little changed today, except that the trees have grown along the canal giving the stretch a more rural feel, and narrow boats are few and far between, mainly confined to rallies these days.

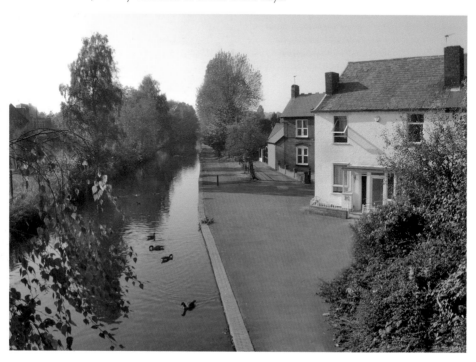

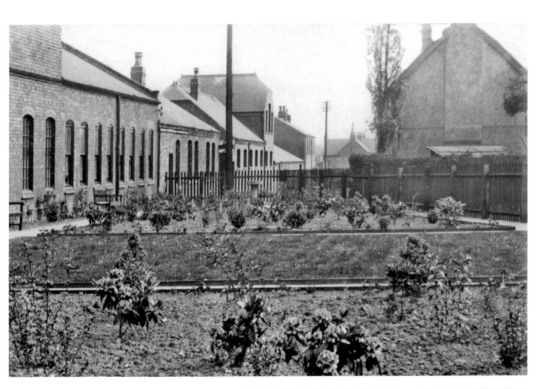

Clay Lane and Ham Baker Ltd

Clay Lane ran from Uncle Ben's Bridge to the railings shown in the old picture, and led to the foundry of Ham Baker & Co Ltd and the gardens next to their offices. The company specialised in castings for the water and sewerage industries. The interior shot shows the heavy foundry in 1930.

The company was acquired by Biwater in 1980. The factory was demolished around 2000, and is now a housing estate. The bottom picture, taken from approximately the same position as the upper one, presents a very different scene with houses where the factory buildings had once been. Even the cottages have gone. The only building remaining is the most distant one, the Sycamore Inn, now a bail hostel.

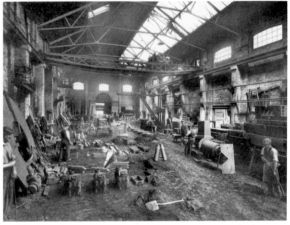

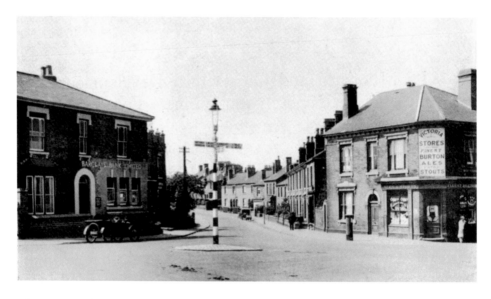

Vicarage Road

Barclay's bank had recently replaced the original Vicarage Road Post Office when this top picture was taken. Parking at the bank caused less disruption in those days than recently, although the problem was solved when the bank closed in 2009, despite it being the last one left in Langley! The 'out-door', or off-licence, is now a heating company, and the little local shop has become the white-painted Olympia Fish Bar. Many of the houses have been replaced, but the remaining block, Vicarage Terrace, is one of the oldest in the area, being built in 1879.

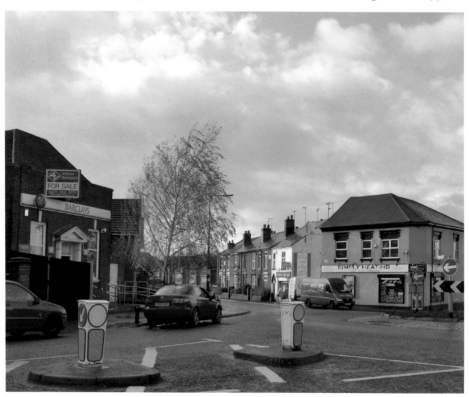

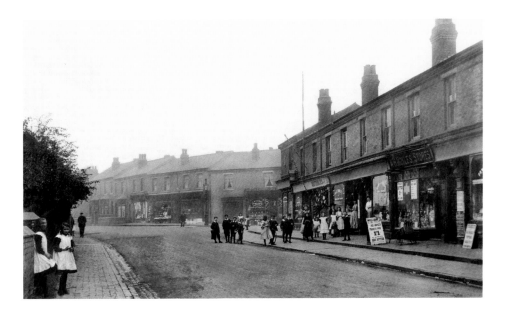

Rood End

Rood End was developing rapidly when this postcard was sent in 1911. The streets were filling with terraced houses and the shops were just ten years old – one has a date-stone 'Peace Exchange Market, 1901', marking the end of the Boer War. Today the T-junction has become a busy crossroads. The shops that used to be the traditional sweetshop, grocer, greengrocer, baker and tailor now offer auto spares, halal meat, a medical centre and fast food delivered to the car! One point of continuity is the farthest shop in the top picture, Mrs A. Oakes, haberdasher, which has grown into A. Oakes, family department store, a well-known source for local school uniforms.

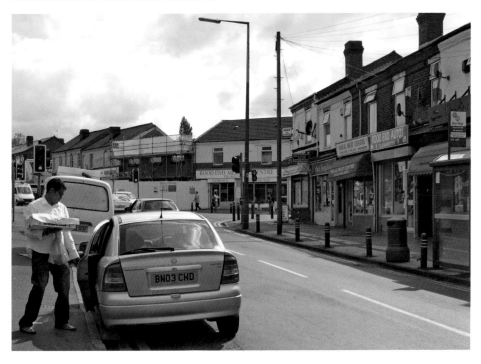

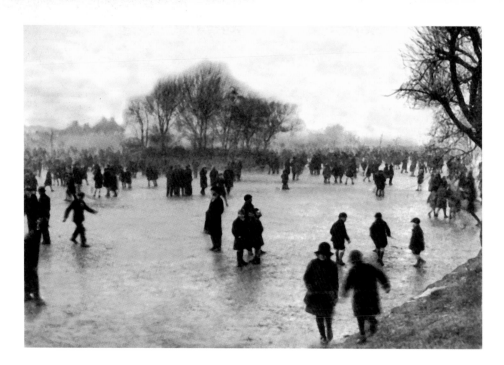

West Smethwick Park

This park straddled the boundary between the boroughs of Oldbury and Smethwick, and when James Timmins Chance opened it in 1895 he stated that it was a gift to both boroughs. It soon became the main recreation area for the people of Rood End. The stream that forms the boundary was dammed to create this pool for boating and fishing. A cold winter between the wars attracted many to venture on to the ice. In January 2010, in contrast, the ice only attracted notices warning people not to walk on it!

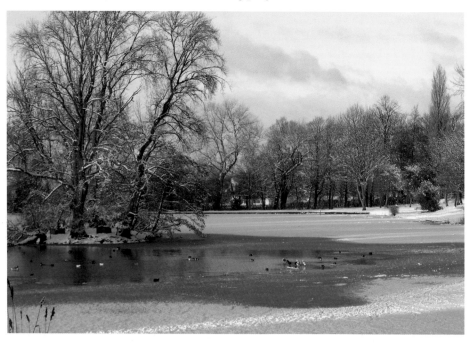

CHAPTER 3
Warley

Warley was separated from Oldbury and Langley for much of the last thousand years, and there were two separate villages within it, Warley Salop and Warley Wigorn. They were all brought together when Oldbury Urban District Council was formed in 1894.

Warley lay off the South Staffordshire coalfield and well away from the industrial development that occurred in Oldbury and Langley from the late 1700s. At the start of the twentieth century, it was open countryside, good fertile agricultural land still dotted with farms, fields, and little groups of cottages. It yielded such good harvests that the area around Broadmoor was known as 'The Glory Hills' from its golden cornfields.

There was one large country estate surrounding the so-called 'Warley Abbey', which actually had no religious connection. The estate, including two farms, was bought by the Birmingham gun maker and banker Samuel Galton jnr in the 1780s. In 1795 he commissioned Humphrey Repton to lay out part of it as the country estate, occupying two sides of a small valley. The farmland was replaced by open grassland, and neighbouring buildings screened with plantations. Repton identified the site for a mansion in the park, but Samuel Galton chose not to build one. However, he allowed his second son, Humphrey, to build there, and by 1820 a Gothic style house, which he named 'Warley Abbey', was complete.

By the start of the twentieth century the population of Smethwick and Oldbury was growing rapidly, and the surrounding farmland was gradually sold off to permit the expansion of Bearwood, mainly as rows of terraced houses reaching right up to the edge of the park. A group of local people managed to buy the Warley Abbey Estate and save it for the people of Birmingham, Oldbury and Smethwick. It became known as Warley Woods. The Abbey survived until 1957 when it was demolished. Since 2004 it has been administered by a Community Trust, and they have greatly improved the neglected estate.

The pressure for housing increased after the First World War, particularly as slum-clearance schemes were started in the poorer parts of Oldbury. The agricultural land around Warley was progressively sold to Smethwick and Oldbury for council housing. In 1928 a large area, including Warley Woods, was transferred from Oldbury to Smethwick.

The country lanes were surfaced and widened as motor traffic grew. A new road between Birmingham and Wolverhampton opened in 1927, cut through farmland on the Quinton side of Warley. This encouraged development along its length. A new Catholic Church, St Hubert and Our Lady of Good Counsel, was opened at the junction with Bleakhouse Road in 1934.

In 1903 a group of local men started a golf club on part of Brandhall Farm, and this was purchased by Oldbury Urban District Council in 1928. This protected an area of open land from the building boom following the Second World War, which surrounded the golf course with houses on the Brandhall and Brook Road estates.

The rural character of Warley in 1900 was completely lost in a little over half a century.

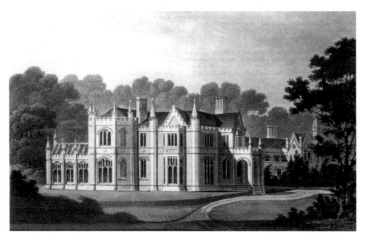

Warley Abbey from an illustration by its architect, Robert Lugar, in his book Villa Architecture, 1828. *The pictures on the previous page show Harborne Lane with Warley Woods to the right. The top picture is an early colour plate taken in the 1920s by Harry Wakeman. The lower shows the houses on the left which replaced Warley Hall Farm.*

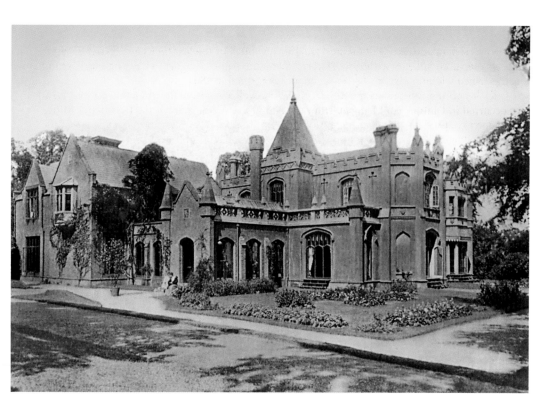

Warley Abbey

This 1900 picture shows the south side of Warley Abbey in its last few years as a private house. When the estate became a public park, the building became a restaurant, a home for Belgian refugees at the start of the First World War, and finally the clubhouse for the golf-course that occupied part of the estate. The main entrance was on the north side, below right. The Abbey was demolished in 1957, and all that remains today is a flat raised area of grass where it once stood, shown in 2007 picture below left.

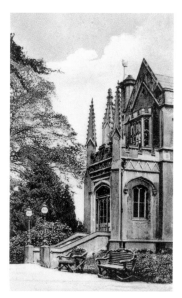

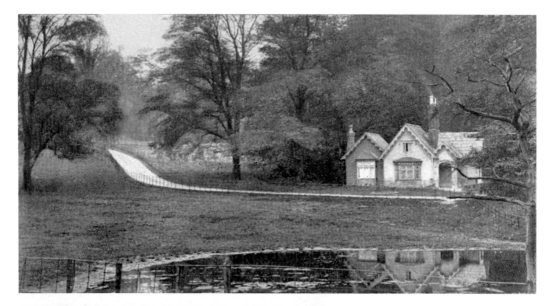

Warley Woods I

Warley Woods was a popular spot for a day out, and also a favourite subject for postcards in the Edwardian era. The cards were often hand-coloured, and these examples show the lodge and pool at the Abbey Road entrance, the 'summer arbour', and the rustic bandstand with Alexander Macomb Chance, who helped to save the park from the developers.

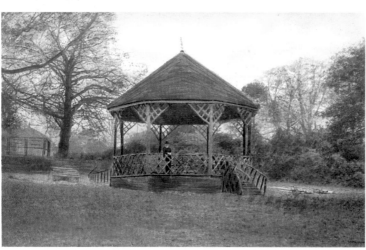

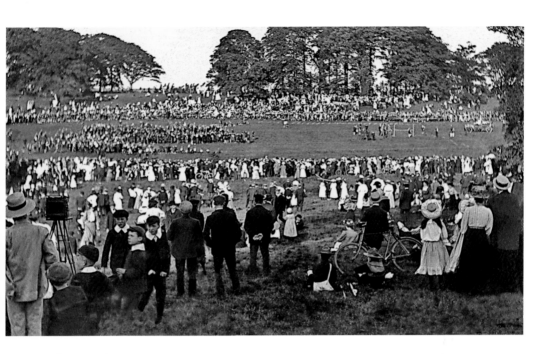

Warley Woods II

The bandstand, lodge and arbour have long since gone, and there is no pool now on 'safety grounds'. The park proved a great success with the public, and a large crowd gathered for events such as the Scouts Gathering in 1909. The car, something of a novelty at the time, was Baden-Powell's. The crowds gathered on the grassy slopes seen in the distance in the lower picture. Under the current community trust management, some of the original park features have been replaced, such as the roof structure over the old drinking fountain, although this no longer dispenses water. They are also adding new features including these bare sculptural tree trunks.

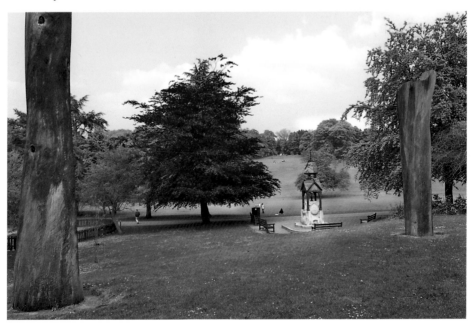

Abbey Road

The rural setting of Warley Woods is evident from this picture taken in the mid-1920s. Abbey Road descends to the entrance of the park, which can be seen to the right and in the distance. The trees along Barclay Road dominate the skyline. At their left edge is Abbey Road Schools, and below them the first new houses have been occupied. Slatch House Farm is just visible behind the gate. Abbey Road was widened just after the top picture was taken, and now the farmland to the left is covered in streets of houses. The old wall, built when the road was widened, has been topped with new fencing erected by Warley Woods Community Trust. This is part of the land transferred from Oldbury to Smethwick in 1928.

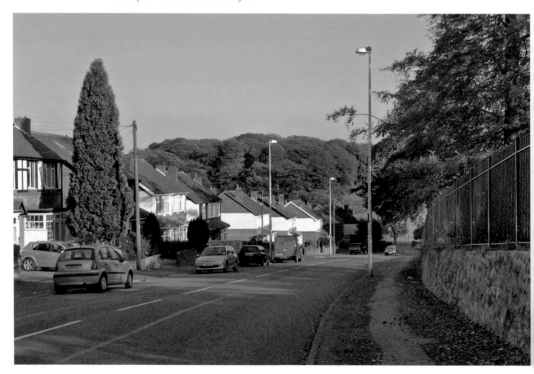

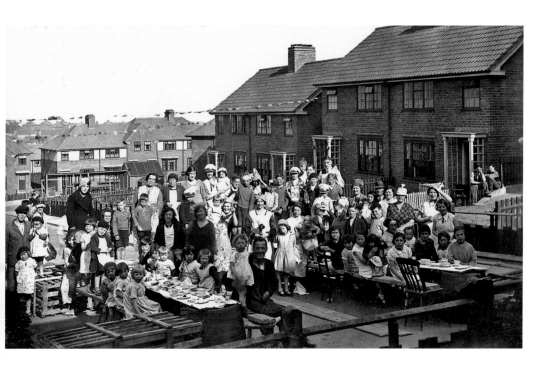

Salop Road

Salop Road is part of the estate built at Warley in the thirties to help in moving people out of sub-standard housing in the town centres. The old picture shows the Coronation party in 1936 in Salop Road. Such events gave an opportunity to get to know the new neighbours.

With the sale of council houses in the 1980s many of the houses have been 'personalised', and it is now difficult to identify the exact location of the party. The photograph below is typical of the estate today, and shows the junction of Edmonds Road with Salop Road.

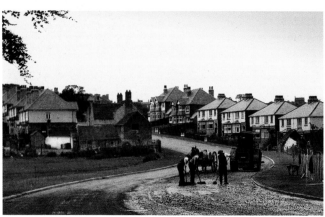

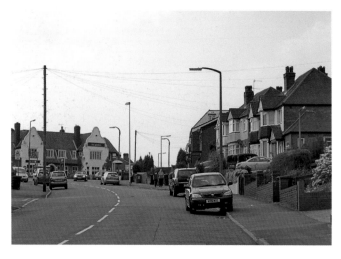

Warley Salop I

The top picture shows the approach to the hamlet of Warley Salop from the Bearwood direction. It involved climbing Pottery Road, which was just a narrow lane before the 1920s, dry and dusty in summer, muddy in winter and impassable when there had been snow. The building on the far right is the George Inn. At the top of the hill the main building, the Old Malthouse, was run as a shop until 1966 when it was demolished. It would fill the gap in the skyline in the present day picture. The road was widened in the mid-1920s and lined with houses. The pottery that gave its name to the road was at the bottom of the hill, and is named on an 1822 map as 'Mr Brettell's Pottery'.

Warley Salop II

Warley Salop was a small ancient hamlet situated at the junction of George Road, Hill Top Road, Pottery Road and Bleakhouse Road. It had a public house, the George Hotel, at least as early as 1822. The old picture shows the building around 1910. In 1937 the trees in the top picture on the opposite page were demolished, and the present building for the George Inn was erected there by Mitchell and Butler's Brewery. Both buildings are still standing, the old one now housing a small supermarket. The first Wesleyan Methodist Chapel was built in the 1850s and replaced by the present building in 1884. It is now part of the King's Community Church. Public house and chapel still dominate the centre of Warley Salop.

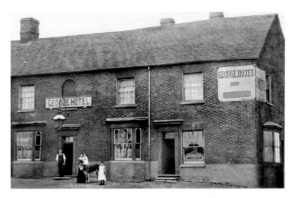

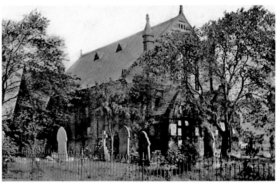

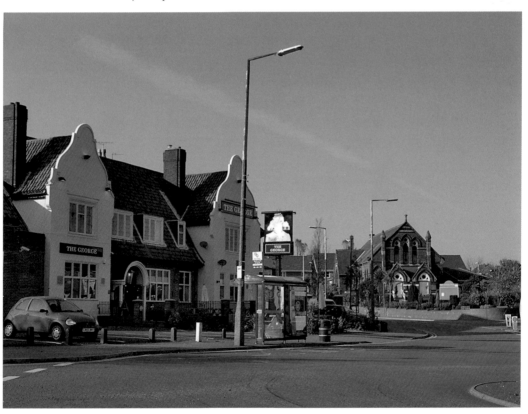

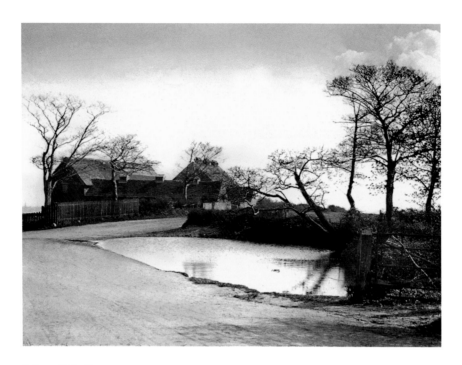

Bristnall Hall Farm

These farm buildings stood at the junction of Bristnall Hall Road and Bristnall Hall Lane with the farmhouse off to the left. In the 1930s Bristnall Hall Secondary School was built in the road to the right of the buildings, and the surrounding fields became a housing estate. One of the farm buildings was the original headquarters of the Warley Corps of the Salvation Army. All the buildings have gone and the pool has been filled in. It is a busy junction where five roads meet, and far removed from the peaceful country scene of the 1920s.

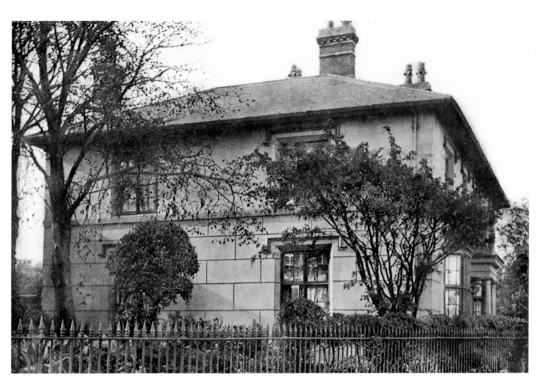

The Beeches

The Beeches stood next to Warley Wigorn School on the corner of Beeches Road and Bristnall Hall Road, a hundred yards from the pool in the picture opposite. It was occupied by the Oldbury brickmaker Benjamin Thomas Sadler in the 1870s, who sold it around 1900 to Elijah Hollins, a solicitor in Oldbury. The area was conveniently close to the industrial and commercial centres of Oldbury and Langley, but enjoyed cleaner air and open countryside. Therefore, it was a popular area for factory owners and professional men to build houses.

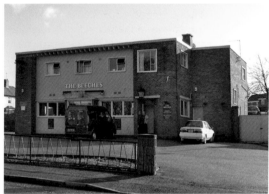

In the 1930s, the owner was Horace Henry Robbins, the income tax inspector for Oldbury. He sold it to Mitchell & Butler's brewery, but it was not until after the Second World War that a very plain public house, The Beeches, was built. Around 2010 the building was converted into a Tesco Express.

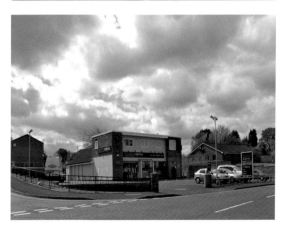

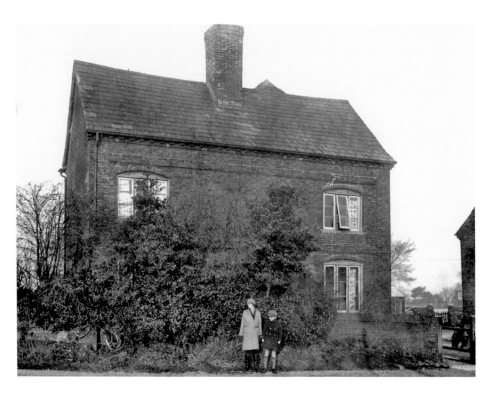

Perry Hill

This farm was one of several run by the Cooper family in the early twentieth century in Warley, and the name 'Coopers' Farm' was used by locals for most of them, causing some confusion. This one was situated in Perry Hill Road, near its junction with Castle Road, overlooking Brand Hall in the valley below. It was demolished after the Second World War when the Brandhall estate was being built. The site is now occupied by the Perry Hill Tavern.

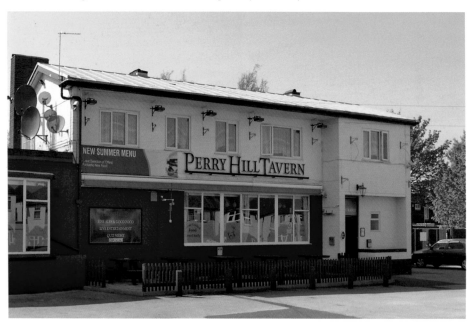

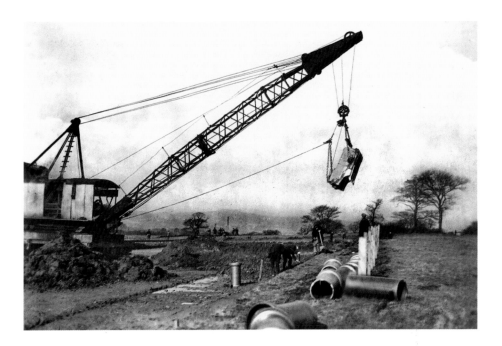

The A4123

The 'New Road' from Wolverhampton to Birmingham was cut through the fields of Warley and Causeway Green towards Bury Hill. A similar scheme had been proposed before the First World War, which delayed its implementation. With high unemployment after the war, the road was started in the mid-1920s, in part as a job creation scheme, and opened in 1927. The old picture shows an American 'devil-digger' in action during construction work near to the present junction with Brandhall Road. The Rowley Hills and a factory chimney at Causeway Green are visible in the background. The modern picture shows the A4123 at roughly the same spot today.

Brandhall I

'Brand Hall' was a grange of Halesowen Abbey in medieval times situated on a tributary of the Tame, which rises near Quinton. Some of its farm buildings and one of its pools survived into the twentieth century. In 1935, when the old picture was taken, it was the club house for Brandhall Golf Course. The golf course had been bought by Oldbury Council in 1928, and to this day it remains a green oasis amidst the houses built after the Second World War. Nothing on the old picture remains today: Brand Hall was removed in the 1950s to develop the Brandhall Estate, houses cover the distant hills and reach right down to the trees bordering the golf course, even the bunker has gone and there is no longer a green at this spot. Nevertheless, the golf links are still well used as the picture opposite shows.

Brandhall II

Broom Hill Cottage once stood alone in the fields below Perry Hill, reached by a steep track. This track is now Tame Road, which runs down the hill into the heart of the Brandhall Estate with its traffic lights, library, supermarket, health centre and the Kings Community Church. Broom Cottage is long gone, but its grassy knoll remains opposite Brandhall Labour Club.

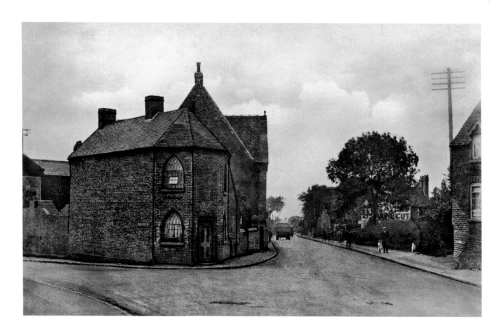

Quinton I

The Quinton toll house stood at the junction of College Road, to the left, and Hagley Road. The toll house and the Wesleyan Chapel behind it were in Quinton township. However, the Hagley Road was the boundary with Warley, and the buildings on the right hand side of the road were in Oldbury Urban District. Today, this road is still the boundary between Sandwell and Birmingham, which annexed Quinton in 1909. The cottages on the far right were demolished long ago to widen the road, but those further down have only recently been removed to provide access to a new supermarket. This was built on the site of the King's Highway public house, itself a replacement for Monckton House or Tinker's Farm. Perhaps the greatest change is the M5 motorway, which passes under the Hagley Road just in front of the cinema on the right.

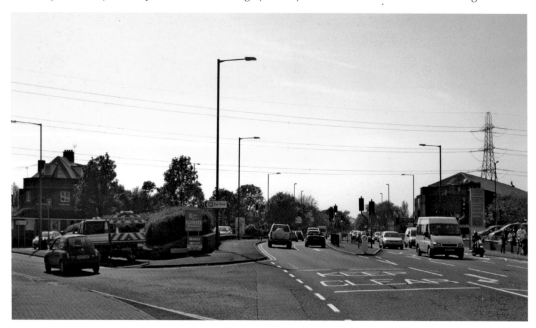

Quinton II

Perry Hill Road was an ancient country lane, linking Quinton and Warley. It was widened in the early 1930s when the first houses were built. The old picture, taken from its junction with the Hagley Road, shows there is still room for ploughed fields and grazing horses at this time. However, this area too would be covered with houses within a decade, although an attempt was made to keep some rural character in the road names, which included Forest, Oak, Chestnut and Holly Road. The clump of trees in the current picture obscures most of the houses built on these fields, but on the right can be seen one of the five pairs of houses built as memorial homes between 1909 and 1954 by various members of the Butler family of brewers, part of Mitchell & Butler.

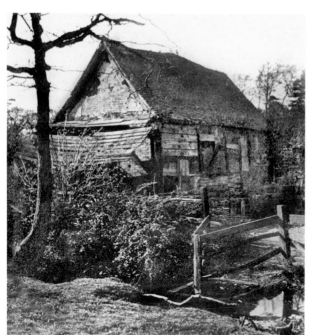

Thimble Mill I

The old water mill had many uses including the grinding of corn and the making of files, but it takes its name from the manufacture of measures for spirits in the eighteenth century. These were called 'thimbles'. In this picture taken around 1890, it looks very dilapidated and it was demolished soon afterwards. The name 'Thimblemill' has been applied to the surrounding area and given to a library, swimming baths, and a public house. The area was in Oldbury until 1928, when it was transferred to Smethwick. Thimblemill House faced the pool across the road, and was demolished when council houses were built in Thimblemill Road.

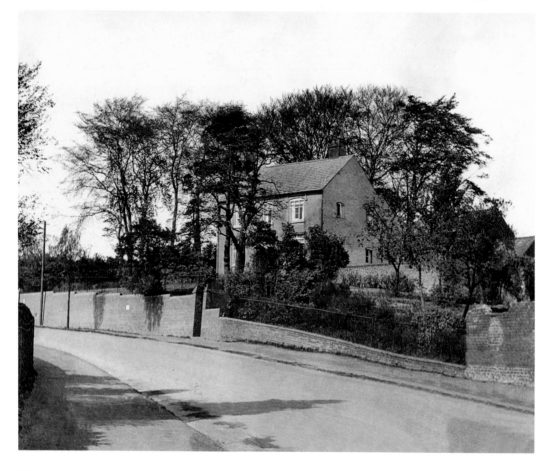

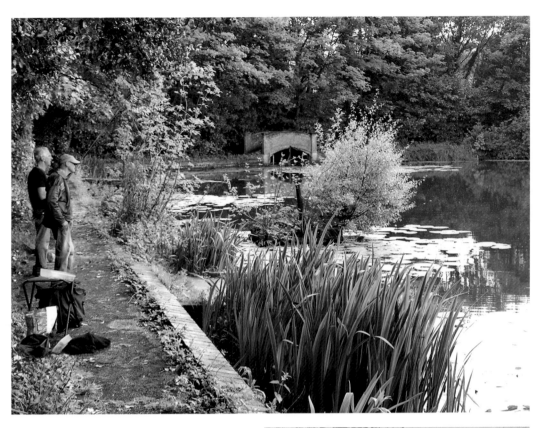

Thimble Mill II

The outfall, which maintains the level of the old mill pool, is still there today, even if the holly trees do obscure the view of the bridge. The rustic bridge has been replaced by a more prosaic concrete one. The whole area is much more overgrown than when it was a working mill, but Thimblemill Pool still provides a quiet spot for today's fishermen.

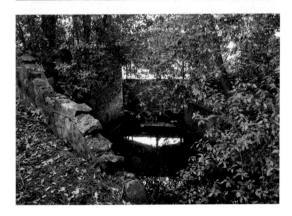

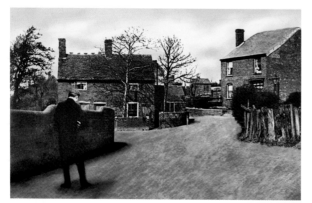

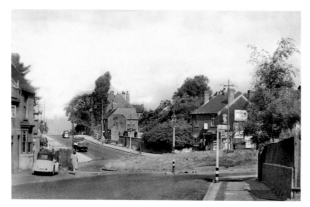

Bristnall Fields

The 'fields' in the name of this old hamlet were the medieval open fields that surrounded it, and it remained an area of farms and fields until the 1930s. For reasons that seem to have been lost, the area around the roads in the top picture was known as 'The Lake'. All the pictures are taken from George Road looking towards Pound Road, with Brandhall Road to the left and Moat Road and Bristnall Hall Road to the right. In the 1920 picture the roads are just country lanes with a cluster of cottages around the Plough Inn, to the left. By the 1950s a large island and demolition of the old cottage has eased the traffic flow. The corner shop on the right is the post office. Today, the scene is very different with most of the old houses replaced, no fields, more shops and even more traffic. The Plough Inn has survived these changes from a 'rural' to an 'urban' landscape.

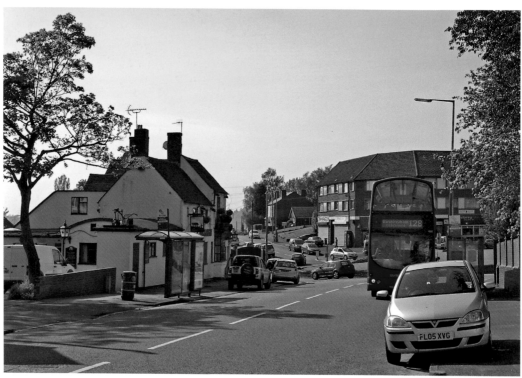